Mr Robert V Carlzon
PO Box 1276
Kingston NY 12402-1276

W9-DEX-870

AMERICAN DRAWINGS

DRAWINGS OF THE MASTERS

AMERICAN DRAWINGS

Text by Bartlett H. Hayes, Jr.

Director, Addison Gallery of American Art

Phillips Academy

Andover, Massachusetts

LITTLE, BROWN AND COMPANY LB BOSTON · TORONTO

A

LIBRARY OF CONGRESS CATALOGING IN PUBLICATION DATA

Hayes, Bartlett H 1904–
 American drawings.

 Reprint of the ed. published by Shorewood Publishers, New York, in series: Drawings of the masters.
 Bibliography: p.
 1. Drawings, American. I. Title. II. Series: Drawings of the masters.
[NC105.H28 1975] 741.9'73 75–11518
ISBN 0–316–35170–9

Published simultaneously in Canada
by Little, Brown & Company (Canada) Limited

PRINTED IN THE UNITED STATES OF AMERICA

Contents

AMERICAN DRAWINGS

Drawing is how Man makes his mark.

Of all creatures, he alone has discovered how to document what he finds around him and to formulate an image of his inward vision.

From whimsy traced and lost in sandy tides of time to superstition rubbed on the surface of a primitive cave, from devotion figured and hardened in yielding clay to pride engraved in heraldic metal, from hard observation penned on fragile tissue to prophetic insights abstractly assembled in a variety of media, drawing testifies to his design.

American drawing partakes of such elemental purposes although with varying degrees of intensity and importance. It exhibits other traits too, some naïve, some sophisticated. During its growth, the Nation has perforce become reconciled with itself and thereby evolved its several characteristics. Disparate peoples have become less so; new unities have emerged. Individuals have stood forth to assert their individualities and have been immersed again among those who have followed, like bubbles that return to the flowing stream. Drawing delineates their memory.

What American drawing discloses, specifically, is that history, understood in terms of political or economic events, is only part of the social story and that until very recently American culture broadly mirrored much of the European scene, both as to motivations and mannerisms. To be sure, the geographical environments in Old and New Worlds were not the same and therefore differences in subject matter are obvious. In the Old World, the village stones, princely courts and inspired cathedrals which expressed an ancestral presence

could readily establish an atmosphere of artistic stability, whereas in the New World a vast wilderness, ever changing, provided no such traditional conformity or security. If artistic taste was aroused at all, it was borrowed from across the sea. Moreover, the habits of human beings are not abandoned in a year, and it was natural for citizens of European countries who migrated to America to continue the ways they knew as best they could and to look to their motherlands for guidance in aesthetic matters despite broken family ties and newfound freedom.

Although an American colonist might have drawn for his own exploration in just the same way that he penetrated westward into unknown territory, it is evident from the way he drew that he was thinking along the lines of what he had seen in his native country. The artisan, or domestic draughtsman, continued to draw as his forebears had drawn; the professional (there were but few) was either trained before emigrating to America (Charles Balthazer Julien Févert de Saint-Mémin, schooled in France, for example) or sought to learn from prototypes gleaned from the homeland across the ocean. With little to serve as a model, his drawing was apt to follow whatever examples might be at hand.

A case in point is the *Battle Scene* drawn by J. S. Copley in 1759. As a young man, Copley was apprenticed to his stepfather, Peter Pelham, a commercial engraver and portrait painter. Pelham had been trained in England and it is therefore to be expected that the youthful Copley would have instinctively imitated the English manner, even though in a provincial way. The drawing in question is continental in style, a fact which can be accounted for only by assuming that in order to learn Copley copied a print (the particular subject and artist are not known) which happened to be available. In striking contrast to this tightly defined composition is the fluid ease with which he has sketched the *Woman Fleeing with a Child* drawn after he had left America for England and had learned the more sophisticated techniques of the day.

Figure 1

John Singleton COPLEY · *Battle Scene*, 1759 · pen and sepia ink, 3½ x 7 inches · Addison Gallery of American Art
Andover, Massachusetts

In his striving to learn from masters of the past and to perform according to the aristocratic taste of his day, Copley was typical, not an exception. Benjamin West, brought up in Pennsylvania, had preceded him by a few years and welcomed Copley as well as other young Americans who voyaged to London for artistic enlightenment. A glance at the drawings of Trumbull, Brown, or Sully, for example, shows the professional manner learned and adopted by these young men as a consequence of their transatlantic pilgrimage. Technically, as well as stylistically, they differ considerably from the innocent and relatively awkward efforts, quaint and charming though they may be, of the anonymous artists which appear elsewhere in this volume, such as the floral drawing, the sinking ship, the girl's portrait, the bridge over The Mohawk (the name of this self-trained artist, Dunlap, is known, as was occasionally the case).

It is characteristic of the self-trained, or natural artist, to be interested in what can be observed because it is easier to follow the lines of the object, or scene, than to contrive a picture from memory, or to invent one. When they occur at the folk level, departures from strict observation are apt to be fanciful, as in the case of the *Flying "Draggon"* where there is no opportunity for embarrassing critical comparison with an obvious reality. However, this trait was not peculiarly American, rather, it was more frequently expressed in America where professional samples were less in evidence than in the Old World.

The same non-professional interest in the outward world is to be found abroad at the same time drawn with the same meticulous attention to observable details with varying degrees of proficiency. The pen drawing of *View of Hell Gate* (a treacherous arm of the ocean between Manhattan and Long Island, New York, as it appeared in 1777) was drawn by a Colonial artist, who was an Englishman (judging from his name, Williams) and who therefore would have drawn the Mersey River at Liverpool in exactly the same way—and possibly did. The three views of the American vessel, Janson, drawn as

if in a comic strip in three successive stages, caught in the ice flow, abandoned and subsequently sinking, is a typical American drawing. On the other hand, it is believed to have been drawn by a Dutchman, for the ship sank off the mouth of the Texel River in Holland. It is included in this volume to emphasize the point that American ships furrowed global waters, harvesting cultural trophies which have become so much a part of Americana, that it is often impossible to know what was or was not the work of an American hand.

Apart from the technical facilities they acquired abroad, Americans who aspired to be artists also followed European interests with respect to subject matter. These interests fall into broad categories, none of which arise from circumstances indigenous to America: biblical topics, or moral paintings—the drawings of West, Allston and Rimmer; the nobility of History—Trumbull's *Sketch for The Death of General Mercer at the Battle of Princeton,* and Vanderlyn's study for the mural in the National Capitol, representing the discovery of Columbus; aristocratic portraiture—St. Mémin and Sully; the close observation of nature, as well as the broader panorama—Audubon, Durand, Doughty, and, later in the century with greater technical ease, Haseltine, Colman, Church and Moran. The latter was born and raised in England, but carried westward the romantic admiration for the grandeur of landscape which was first identified with the Catskill Mountains and the banks of the Hudson River. However, although the land itself was American, these artists all drew it in much the same manner as their 19th-century European contemporaries drew the English mists of the Lake Country, the sunsets of the Rhine, or the theatrical scenery of Switzerland.

The veneration of classical antiquity is an artistic import which most closely parallels American political and social history, especially during the first half of the 19th Century. The great republics of the past were intellectual quarries, not only for notions as to man's conduct, but also for his education and the ideal symbolism of both. The sculptural representation of Leutze's *Head and Hands,* more like a rendition of stone than flesh despite the use of

Figure 2

Thomas COLE · *Temples at Paestum,* January 1844 · pencil on paper, 5⅟₁₆ x 7¹⁵⁄₁₆ inches
Courtesy of The Cooper Union Museum, New York

red crayon to give warmth, Agate's *Indians Lamenting,* gesturing more like Roman statues than Aborigines, and the classical detail in Kollner's precise drawing indicate the range of the influence. Indeed, the land was costumed in Classicism from refined domestic dwellings by Bulfinch to tentative temples later to be incorporated in the romantic utopian paintings of Thomas Cole.

Times changed, however, even as they had in centuries gone by and other European influences fashioned the landscape anew as Cropsey's *Gothic House,* notwithstanding a lingering *Tradition* to be found toward the end of the century as in the symbolic figure by Kenyon Cox.

Probably the most far reaching change to occur in the Western World since Classical times was the rise of an industrial order to replace a handcraft and agrarian society. This too was imported from Europe. For some reason, probably because the significance of the shift was not sensed by artists whose interests were focused either on the locally familiar or on proven precepts in foreign art, there is very little in the repertoire of American drawing to reveal an awareness of the dynamic force which a manufacturing society was to be. To be sure, occasional idealized prospects of factories were in demand, but the practical life had little to do with art unless it touched the emotions in the form of sympathy, sentimentality or humour.

It was the genre, or anecdotal interest which lured the draughtsman's eye. And the very existence of the word *genre* indicates that drawings of the American scene have their counterparts in France, England, Germany and Italy too. It was an important interest in America primarily because it was essentially domestic, appealing to the populace, and secondarily because there was but a small body of sophisticated taste to dominate it, as was the case in Europe. Consequently, drawings, exhibiting a wide range of technique, such as those by Mount, Edmonds, Maurer, Johnson, Potthast, Homer, Shirlaw, and even Remington (as the Wild West came into prominence) are sometimes thought to be exclusively American. Considered from the standpoint of subject matter,

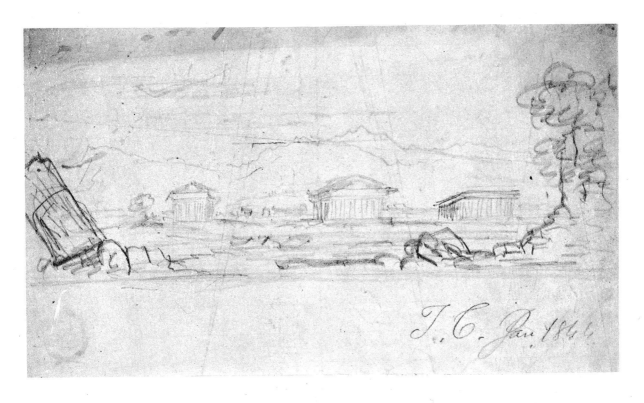

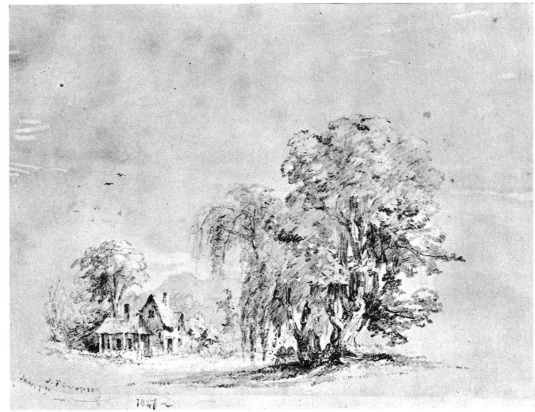

Figure 3
Jasper F. CROPSEY
Gothic House, 1847
crayon, Chinese white and
blue wash on paper
8¼ x 11⅜ inches
Courtesy of
The Cooper Union Museum
New York

Figure 4

Kenyon COX • *Tradition*, 1898-1899 (Study for the Mural *Common Law* for The Appellate Court, New York) • pencil on paper 15⅛ x 19⅛ inches • Courtesy of The Cooper Union Museum, New York

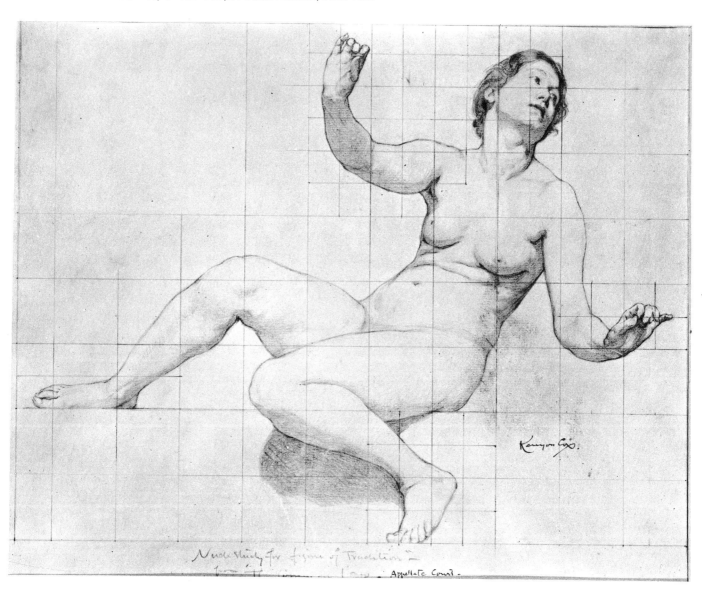

indeed they are; but as an art form they definitely are not, which is no reflection on their quality as drawings for, in this area of popular artistic performance, there is little variation from land to land.

The American artist's focus on foreign concepts, toward the end of the 19th Century, arose chiefly from a dissatisfaction with the want of sensitivity and artistic patronage in America. Patronage, such as it was, tended to ignore native work in favor of prestige on the other side of the Atlantic fence. Artists, such as Whistler, Sargent, and Cassatt preferred to live in the more sympathetic surroundings which they found abroad and their drawings are rooted there rather than at home. This is not to say that they worked in a specific European idiom, it would be difficult to define any such thing, nor that their work was always the same, (the two drawings by Sargent illustrate his versatility) but rather that all drew in a way which, with personal touches excepted, had been developed by Europeans beforehand.

At this juncture, however, innovation begins to gain importance in America both as a standard of performance and of evaluation. Technological changes in the American environment demanded an acceptance of new things and many artists took a fresh look. The looking differed widely according to the way each artist adjusted himself to the complicated developments of the 20th Century. Whereas a hundred years earlier, the appearance of an object normally determined how the image was to be drawn and most artists regarded a specific object from a somewhat similar objective point of view, ideas now began to exert a more important influence on the formation of the image. Because ideas are personal, the various images revealed differing subjective points of view. Each artist now tended to become, as it were, a movement in himself.

For example, the romantic drawing of a sunset by Church is obviously by his hand (at least to anyone who knows his work well), yet several other artists at the same time would have drawn the same scene in much the same way. On

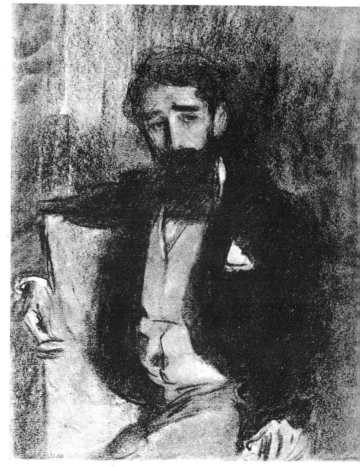

the other hand, the drawing *Walking Away from the Sun* by Hood is so exclusively personal that it could be assigned to no one else. Consequently, it is not only difficult, but probably inaccurate to put overlapping influences on modern American drawing into preconceived categories. Nevertheless, certain similarities and contrasts are discernible which, if strict chronology is disregarded, make it easier to see the subject as a whole than if each drawing were to be considered in isolation.

One category is, for example, the scintillating emphasis on the physical nature of light as developed by Impressionists abroad which appears in the work of American artists such as Garber, Weir and Prendergast. Another category is seen in the work of Dickinson and Demuth, who fragment the scene in order to accent the two-dimensional surface. Consequently, these drawings are not so much *on* the paper as the paper is *in* the drawing, playing a positive part in the organization of the design and producing a fresh concept of pictorial reality—although in the case of Demuth's *Plums* there is an unexpected superficial recall of the flattened, *Floral Theorem Drawing* of nearly a century earlier. Indeed, it is characteristic of history that new things are almost always pyramided on old ones and the best estimate of the nature of what appears to be new is to compare and contrast it with earlier attitudes.

A third category is the attitude toward satire: the powerful, direct symbol of Nast's political jibe at New York's Tammany regime (which, along with his other pungent caricatures, was largely responsible for the exposure of the Tweed Ring scandals nearly a century ago) nevertheless lacks the bitterness of Levine's more direct protest against the decadent society of recent time. Again, the device by which Palmer Cox discloses social foibles in his illustrated narrative of the Brownie's Adventures is by no means so convincing as the philosophic penetration with which George Herriman slyly ridicules comparable human failings. The *Krazy Kat* sequence wittily underscores the too common tendency to be over-positive about the accuracy of partial knowledge; a half century earlier, Cox merely quaintly suggests that people ought to avoid putting themselves in awkward positions.

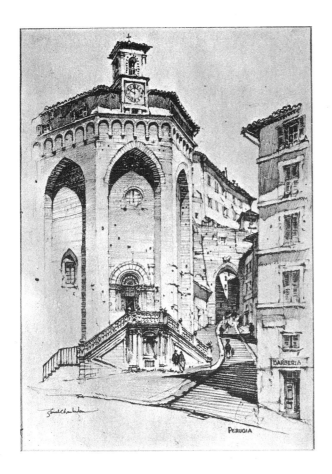

For a time, the modern artist tended to turn from the formal rendition inherited from the 19th Century to the informal scene: witness Chamberlain's precise view of *Perugia* compared with Hirschfeld's quixotic glimpse of *Americans in Paris,* or Sterne's anatomically studied *Nude,* compared with Marsh's boisterous beach group, or Bellow's geometrically designed *Ringside Seats,* compared with Luks' quickly pencilled quintessence of a man plucking game.

But other artists soon sought more than the informal event and what may be noted as a fourth category, a new inventive formality, arose which varied in character from artist to artist. Hartley's *Still Life* is an example which still retains something of the French artist, Cézanne's development of a rationalized representation of form and space while avoiding the ordinary optical illusion of both. This involved a slight stereoscopic distortion of the object from the way it would normally have appeared in a single point of view. It is as if one were to move the head slightly and simultaneously draw what could

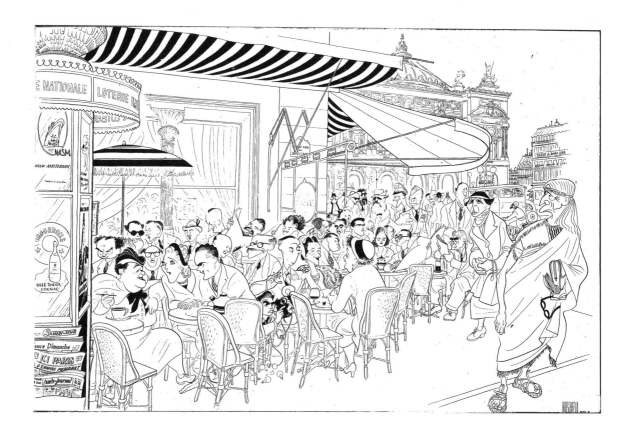

be seen from both positions in order to include more of the unseen surface than would actually be possible to see. It was an intellectual exercise which, historically, parallels a shift from fixed concepts to relative ones occurring in many areas of modern life. Again, the impetus came from abroad and through the sensitivity of alert Americans was incorporated in the evolution of Art in America.

There were other Americans who helped in the quest for a way of drawing which would be appropriate to the new age: Weber, who was in Paris in 1912 at the time the Cubists were experimenting with a new image of form derived from ritualistic African sculpture, joined in to see for himself what the new ideas could amount to. Sheeler, following instead the lead of the photographic medium, created abstract still lifes distilled from the optical exactitude of the camera's lens, including in the example shown in this volume, the obscure reflection of himself in the darkened glass. Kuniyoshi took elements of the natural scene and recomposed them in the way that words might be juggled in a sentence. Each detail, in the ideographic Kuniyoshi style, is like

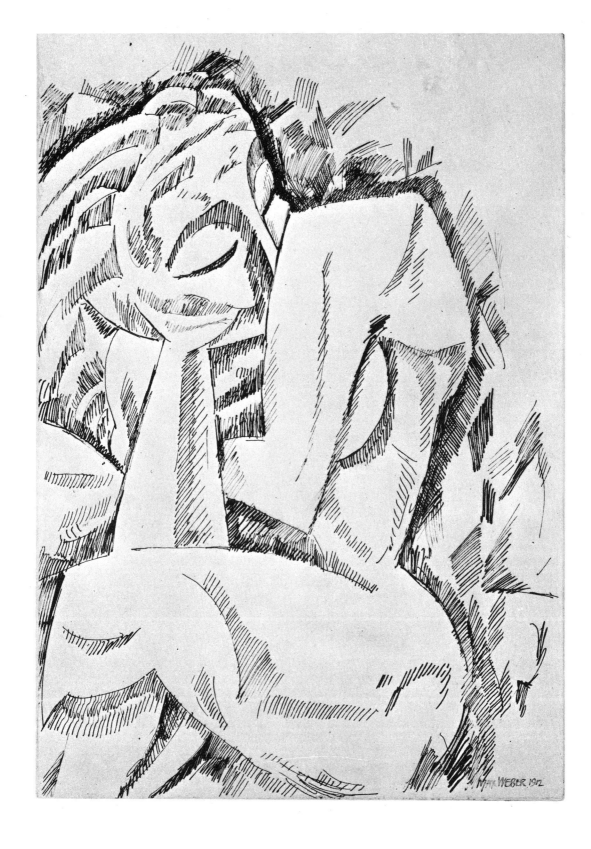

24

Figure 9
Max WEBER · *Figure,* 1912 · ink drawing
12¼ x 8¾ inches · Private Collection

a pictorial word (sky, hill, tree, boat, line, fish, man, Doris) and all are pieced together, as if in a poem to produce a lyrical interpretation of the scene, not a mere reproduction of it.

The pictorial identification with literature, through calligraphy, is perhaps yet another category that possesses importance as an historical phenomenon of present century drawing, because it represents the removal of arbitrary barriers between the arts and brings them together as unified aspects, rather than separate conditions of human experience. Mark Tobey has long displayed his involvement with this quality of vision which he seems to have derived from the culture of the Far East in a highly personal way. *Long Island Spring* is drawn with individual pencil strokes which anticipate the greater abstraction of his later work. In quite a different manner, the ornamental *Bird* by Kelchner is drawn with flourishes of the pen more commonly employed in writing. Kelchner was one of a small group of men who had been trained in the Spencerian style of penmanship that possessed a special vogue toward the end of the 19th Century following belatedly on the heels of a much more popular movement of about fifty years before. These latter day artists of the pen took special pleasure in sending decorated envelopes to each other across the country, so decorated at times that letter carriers had difficuly in reading them. Mere scraps of paper often served on which to practice. The flow of the hand had to be sure; a mistake, like the slur of a fancy skater, was irretrievable. Dozens were turned out and followed each other like falling leaves into the wastebasket before a satisfactory drawing was set aside. These drawings are quaint, accomplished and relatively minor as an art form, but serve as a foil to accent different qualities of line in other types of drawing where the line, as such, exhibits both studied and impromptu significance. By contrast, the ductile, but thoughtful variation in the outline of Graves' *Bird Attacking Stone* describes form, space and character, whereas Kelchner's swift flourish of the pen is little more than that.

26

Figure 10

Mark TOBEY · *Long Island Spring, 1957*
sumi ink, 24 x 19½ inches
Mrs. Marian Willard Johnson, New York

The calligraphic quality of the lines in *Jonquils* by Kline is more impor-
tant than the fact that the inspiration for these lines was a bouquet of flowers.
Knowing Kline's later, more abstract painting, one can perceive a logical
antecedent in drawings such as this. Indeed, comparing it with the equally
sensitive childish drawing by Ben Shahn (childish certainly because it is a
drawing of wide-eyed child) or comparing it with a no less sophisticated draw-
ing, *Windshield Mirror,* by Stuart Davis (sophisticated because it requires true
sophistication to draw what one is looking at backward while going forward—
symptomatic of a lot of modern history), it is possible to sense the perceptive
individual emphasis to be found in the linear quality of much modern
drawing.

Examples of this personal sensitivity are readily multiplied: compare the
careful drawing of the *Portrait of the Artist's Daughter, Mary* by Thayer,
wherein the emphasis is on the total head rather than on the particular char-
acter of line—compare it with the contour lines by which Nadelman has drawn
a generalized sculptural head; or again, compare the dramatic drawing of a
soaring *Buzzard* by Wyeth, where the total image commands attention, with
the articulated pen strokes that detail the feathers of Steinberg's *Hen.* Perhaps
the ultimate in the somewhat complex interrelationship between the "draw-
ing" of word symbols and the "writing" by which an object may be visualized
is to be found in the work of Shahn for whom image is concept, word is con-
cept and the two are joined as dual expressions of human emotion and intel-
lect. He draws the ritualistic *Chanukah,* both as a symbol and a reality just as
he draws the reality of the written symbols which accompany it. In one sense,
nothing could be more realistic than this drawing; in another, nothing more
abstract. The drawing thus poses a philosophic question, "What is reality in
Art?" Nor does it find an answer in Perle Fine's equally philosophic, yet nebu-
lous abstract representation of simultaneous substance and non-substance.
Reversing the usual question, one might ask, "How does one draw a begin-
ning?"

27

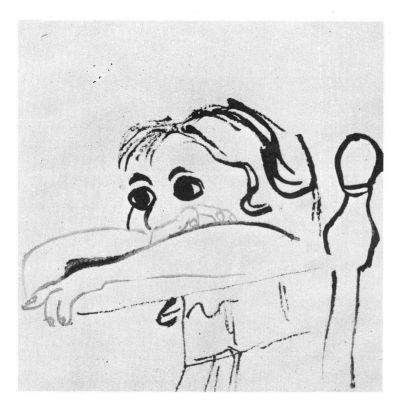

Figure 11

Ben SHAHN • *Study of a Child*, n.d. • brush drawing, 5 x 5 inches
The Phillips Collection, Washington, D.C.

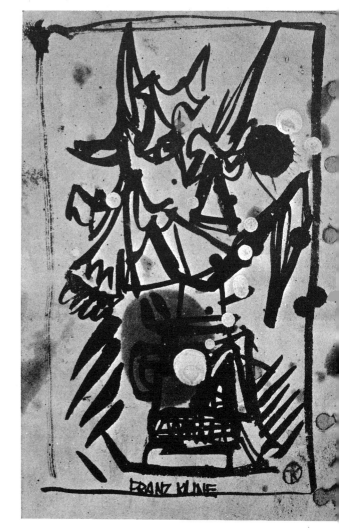

Figure 12
Franz KLINE
Jonquils, 1947
brush drawing (black and white ink)
5½ x 3½ inches
Mr. and Mrs. I. David Orr
Cedarhurst, New York

28

Abstraction is probably the most all-inclusive category to contain the many ramifications of modern drawing. Indeed, all drawing is to some degree abstract in that the illusion is never quite as extreme as in a painting. As an analysis of historical change, one can examine drawings in which the emphasis is primarily on what is represented, in others the emphasis is on the character of line, shape or composition without particular concern for what is represented; in short, the emphasis is on the aesthetic quality of the drawing itself: Stella's *Pittsburgh Winter* is an evanescent representation and yet it is objective by contrast with the still greater intangible quality of air and space in Feininger's *Blue Barque*. Surrounding Hopper's *Locomotive* is what might be called a space-while-time-is-suspended quality. It is the space of experience by contrast with the abstracted space-intervals, as if they were material screens that define Hofmann's *Provincetown*. The latter landscape is a drawing in which the interval (or void by 19th-century standards) becomes a positive element, a measurable reality.

Contrasts like the foregoing represent considerable differences from the simple differences between folk art and aristocratic art which distinguishes drawing in the early years of American history. To seek a reason for the difference is to learn that the change from a horse-drawn society to one which is impelled by engines must automatically be accompanied by changes in artistic reactions. The history of American drawing presents, as was suggested at the outset, a different story from the mere history of increasing socialization. Even though an abstraction is a generality, that kind of generality is found to be extremely personal as the 20th Century advances.

Sometimes, for example, the process of abstracting resulted in very specific images: John Marin painted the Seine River with a new semi-abstract vision in 1909. Several years later, abstracting, or generalizing still further, he displayed in a gallery exhibition what he called his favorite water color. Next to the picture was affixed a statement which, in substance, asserted that "anyone who likes any other examples of my work and says he doesn't like this doesn't like my work at all."

"Who does or does not like my work" has always been the artist's natural concern. In the last fifty years, the relationship between observer and artist has altered as much as the styles of drawings themselves. Formerly the layman understood the artist at a glance, now this is not always the case. The change in point of view over a period of time is no more clearly drawn than in the contrast between the exquisite rendering of a city dwelling by Charles Bulfinch in the early 19th Century and the poetic expression of the relationship between man and his place in the world as has been so graphically rendered by Frank Lloyd Wright. In much the same way that Hofmann gave order to space, in much the same way that Gorky found meaning through invention, in much the same way that the spirit can be envisaged, not only by a preconceived symbol (witness Nelson's *Angel*), but also by the power of an abstract image (*The Study for "The Furies"* by Roszak), or by the human compassion portrayed by Bloom or Baskin, Wright has felt and defined the strict requirements of flexibility of the space in which man finds himself (as represented in the plan of the Ullman house) and has invented bridges to lead to the impossible (as seen in the Doheny house adapted to the precipitous walls of a canyon). If in early America there were differences between gentry and yeomen, between literate and illiterate, the cultural differences today are found between people who are visually sensitive and those who are not. Perhaps very recent artists have re-created earlier designs (*American Hay* by Robert Indiana) in order to ask "Where do we now go from where we have been?"

In conclusion, a few words may help explain this particular selection of drawings:

To do justice to the abundance of drawings produced in America within the scope of this volume is possible only by confessing the impossibility. For every example selected there are hundreds more and for every artist represented many others are equally meritorious.

The selection is arbitrary and personal. To some extent, it is accidental. By no means is it casual. Each decision has been made after much accepting, comparing and rejecting. A decision, like a drawing, is no more than an arrangement of boundary lines and these vary according to personality and judgement.

In the present instance, the boundary lines have been fixed by certain criteria:

First, that the author should like the drawing.

Second, that the word *master* should be interpreted liberally. Drawings by unskilled hands have been included along with those by skilled hands. The quality of each type of drawing, judged in its own terms, has been the basis of choice.

Third, that it is desirable to seek a balance between sketches, or studies, and drawings that were intended to be complete in themselves. Here technical characteristics are of small importance. For example, the comic strip drawing by Herriman is not "realistic," but is, nevertheless, a "finished" drawing, whereas the "realistic" hand of Belshazzar by Allston is a study, not an end in itself.

Fourth, that media such as water color, pastel and even oil may serve as examples of drawing if the draughtsmanship (whether by pencil, pen or brush) is particularly evident. Again, opposites can clarify the point. The drawing by Rauschenberg, wherein pencil is importantly employed, actually resembles his larger paintings in character, whereas the painted *Study for the Portrait of Professor Henry A. Rowland* by Eakins is essentially a drawing in the oil paint medium.

Fifth, that draughtsmanship is not solely limited to picture-making in the conventional sense, but that good craftsmen are also good artists. After all, examples of ancient Greek drawing are virtually unknown except for what has survived in pottery and metalwork.

Sixth, that, because situations such as the foregoing tend to produce variety, variety itself becomes an historical American characteristic. Indeed, if the *melting pot* metaphor is valid as a pat description of American society, then variety constitutes its unity.

This, then, accounts for the seventh criterion, namely that it is illuminating to represent, as summarily as possible, not all but something of the many facets comprising American history. Consequently, where several artists illustrate a particular movement, one or two have been chosen rather than more; where others are atypical, as has been the case especially in the past two decades, their exclusion is for want of examples conveniently at hand. These two considerations explain the willful absence of assorted names such as Stuart, Morse, Blythe, Kensett, Inness, Ryder, Sloan, Davies, Motherwell, as well as the presence of others less well known. The decision to demonstrate historical change also accounts for the smaller percentage of drawings culled from earlier centuries than from the present. In the earlier years, change was not so swift as in recent times. Consequently drawings did not differ so radically one from the other as they do now. On the other hand, in seeking to adapt themselves to modern complexities, individual artists have increasingly played a more discreet interpretive role.

Ultimately, if the drawings of 18th-and 19th-century America reflect strong European influences and the drawings of modern America display distinctive personal motivations, the phrase *American Drawing* as a national phenomenon, is open to question. Here, then, is the final criterion used in assembling the list, namely that no selection of drawings can be definitive, but that it can demonstrate how the increasing aesthetic resourcefulness of individual artists counters influences leading to mass conformity. Drawing thereby marks the expanding democracy of culture in America.

November 3, 1964 BARTLETT H. HAYES, JR.

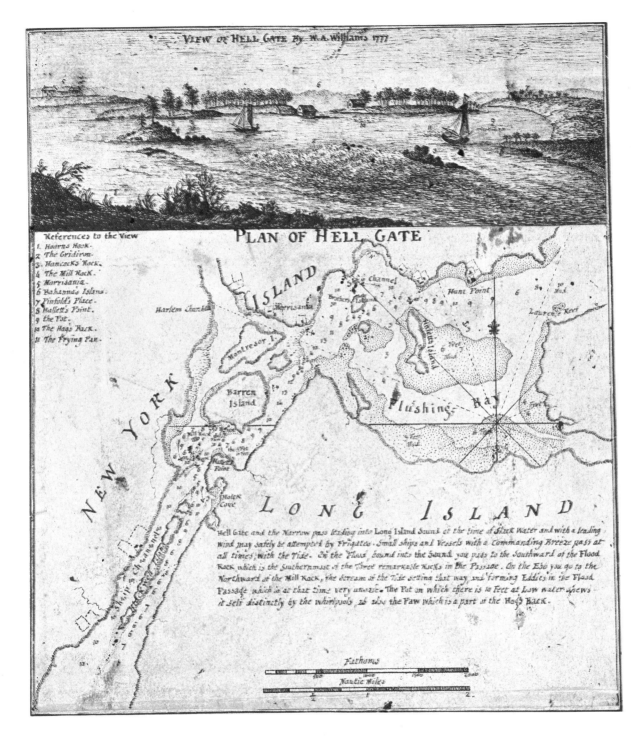

Plate 1

W. A. WILLIAMS • *View of Hell Gate* (detail), 1777 • black and red inks on paper, 21½ x 16½ inches
Courtesy of The Cooper Union Museum, New York

Plate 2

John Singleton COPLEY · *Woman Fleeing with a Child* (studies for "The Death of Major Pierson"), 1783 · black and white chalk
13¾ x 22¼ inches · M. and M. Karolik Collection, Museum of Fine Arts, Boston, Massachusetts

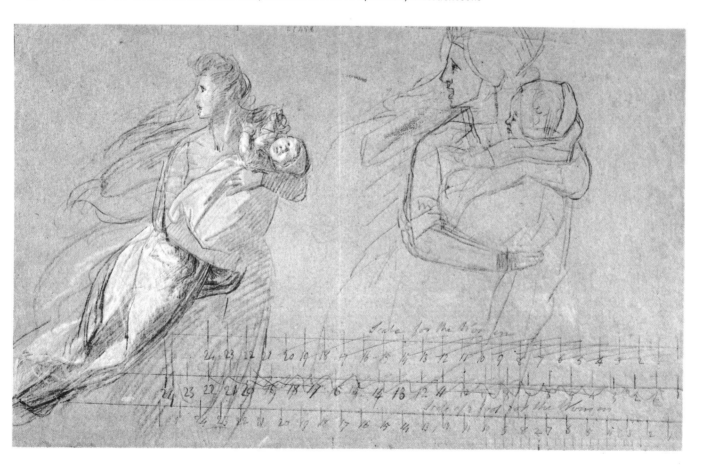

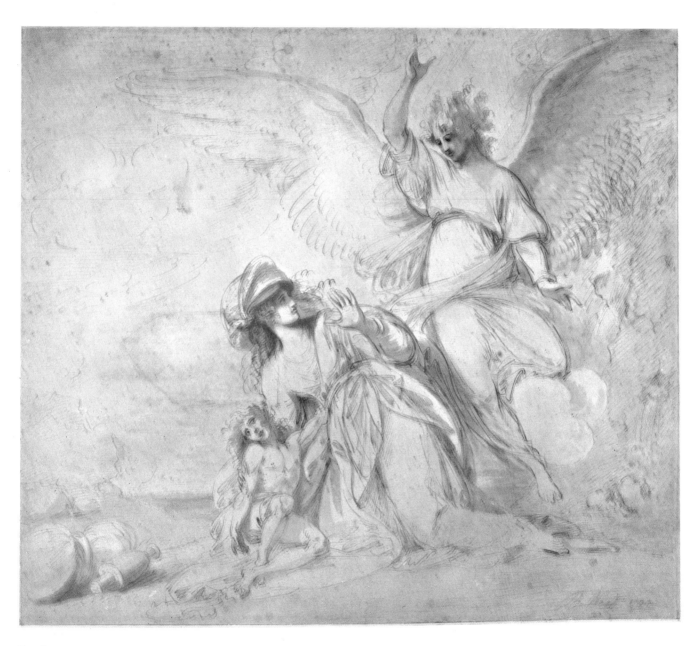

Plate 3

Benjamin WEST • *Hagar and Ishmael,* n.d. • pen and sepia ink and blue water color, 17½ x 20¼ inches
Addison Gallery of American Art, Andover, Massachusetts

Plate 4

Frederick Styles AGATE · *Indians lamenting the approach of the white man*, n.d.
pen and ink, washed, 8¹⁵⁄₁₆ x 8 inches · The Metropolitan Museum of Art, New York
Gift of James C. McGuire, 1926

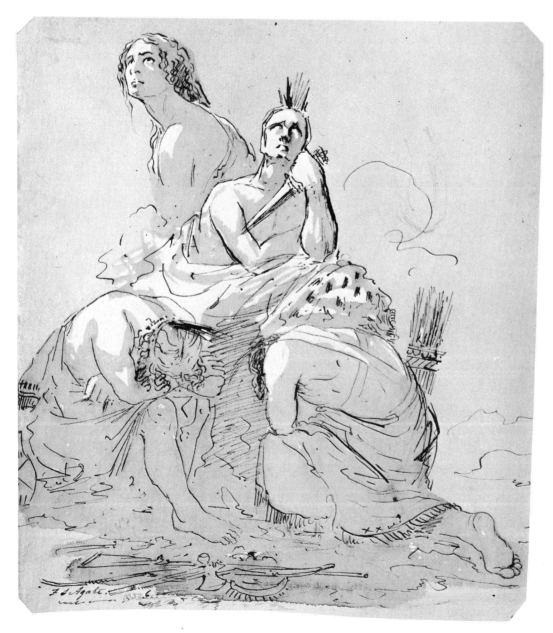

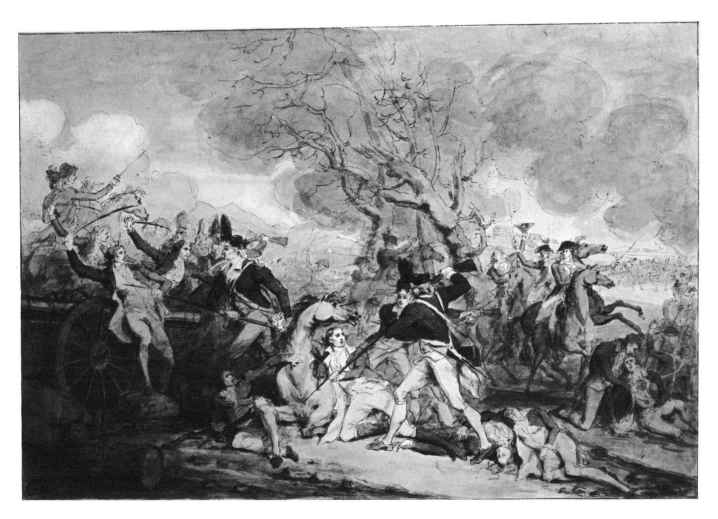

Plate 5

John TRUMBULL · Preliminary sketch for *The Death of General Mercer at the Battle of Princeton*, c. 1786 · ink and wash on paper
10½ x 15½ inches · Princeton University Library, Princeton, New Jersey

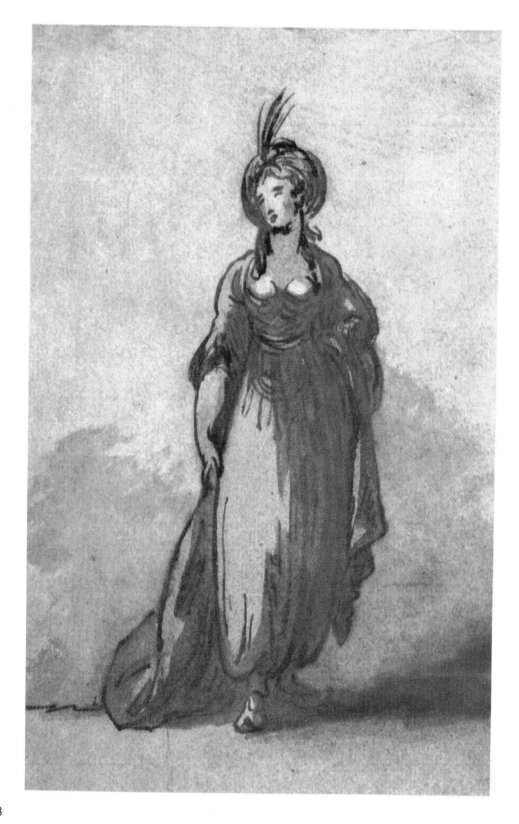

Plate 6

Mather BROWN
Woman, c. 1800
pen, ink and water color
8 x 5¼ inches
Addison Gallery of
American Art
Andover, Massachusetts

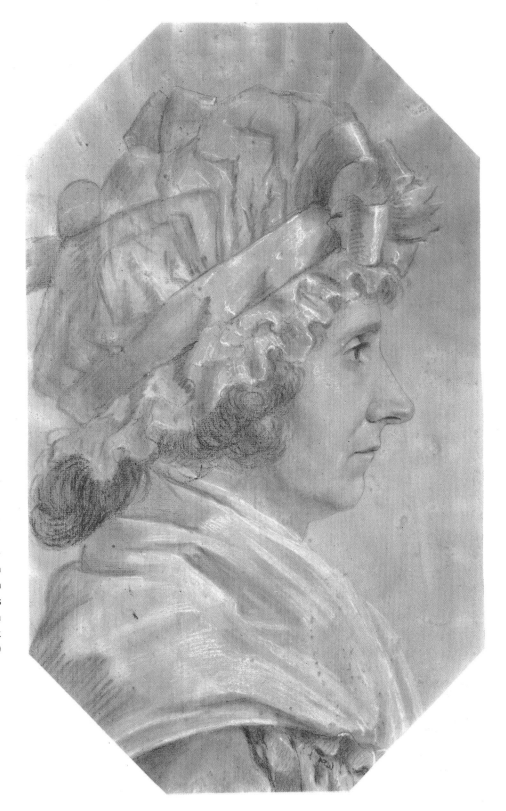

Plate 7
Charles de SAINT-MEMIN
*Mrs. George Clinton
(Cornelia Tappen)*, n.d.
black and white crayon on buff-
colored paper covered with
opaque pink wash
21⅜ x 13¾ inches
The Metropolitan Museum
of Art, New York
Anonymous Gift, 1940

Plate 8
ANONYMOUS · *Girl's Head*, c. 1835
charcoal and white crayon, 21½ x 16½ inches
Private Collection, Andover, Massachusetts

Plate 9
Thomas SULLY · *Page of Sketches*, c. 1825 · pen, ink and ink wash, 8¾ x 11½ inches · Addison Gallery of American Art
Andover, Massachusetts

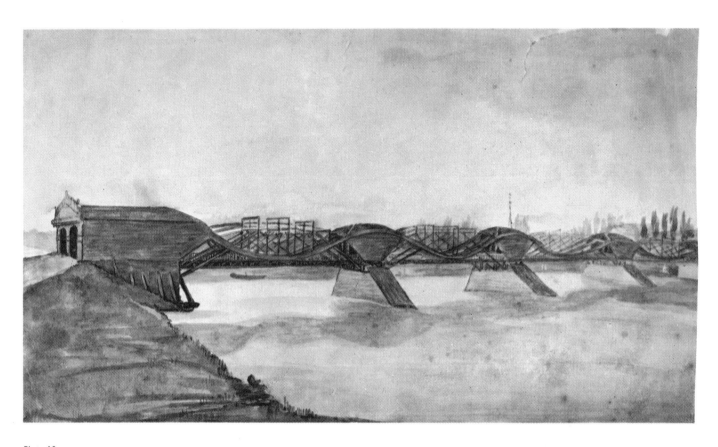

Plate 10

William DUNLAP • *Mohawk Bridge*, 1815 • pencil and water color, 7⅜ x 13¼ inches • Addison Gallery of American Art
Andover, Massachusetts

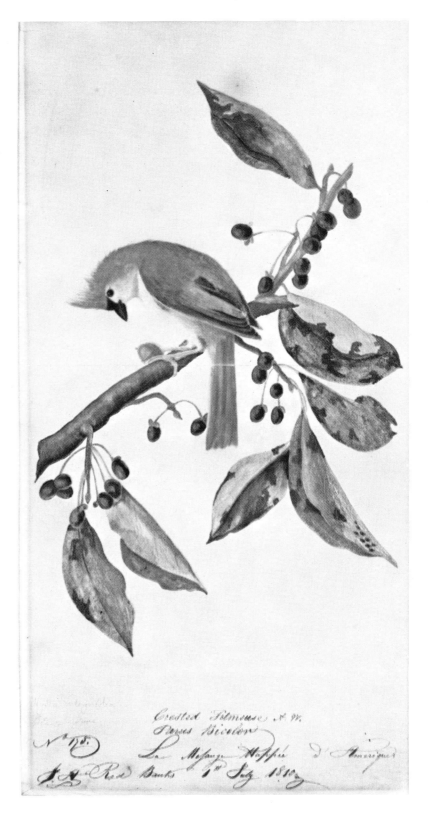

Plate 11
John James AUDUBON
Crested Titmouse, 1810
pencil and water color
16½ x 8½ inches
Addison Gallery of American Art
Andover, Massachusetts
Gift in memory of F. Abbot Goodhue

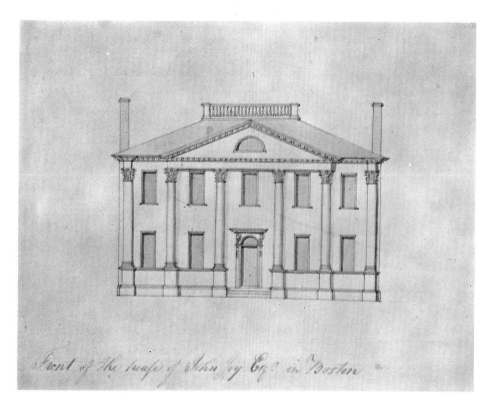

Front of the house of John Joy Esq. in Boston

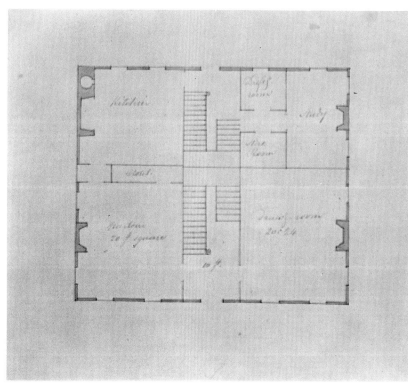

Plate 12

Charles BULFINCH
John Joy's House and plan, c. 1791
pencil and ink
approximately 6 x 9 inches
Boston Athenaeum
Boston, Massachusetts

44

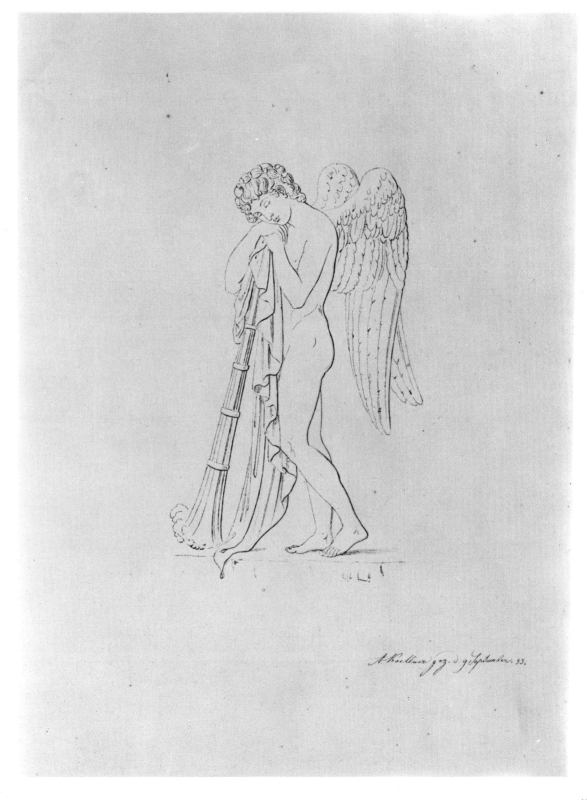

Plate 13
Augustus KOLLNER
Cupid Leaning on a Column
1833 · ink drawing
5¾ x 3¾ inches
Philadelphia Museum of Art
Pennsylvania

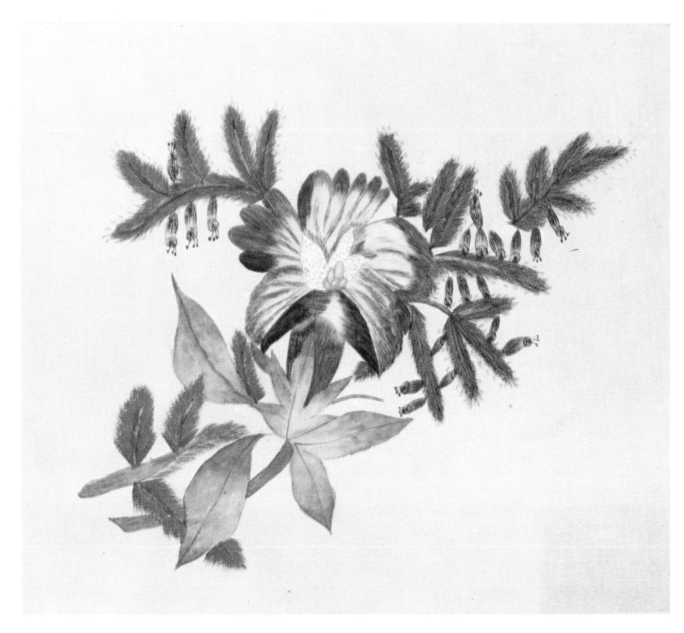

Plate 14

Possibly by E. FOSTER • *Floral Theorem Drawing*, c. 1850 • pencil and water color, 7¾ x 9¾ inches • Andover Historical Society
Amos Blanchard House, Andover, Massachusetts, Gift of Miss M. Florence Kimball

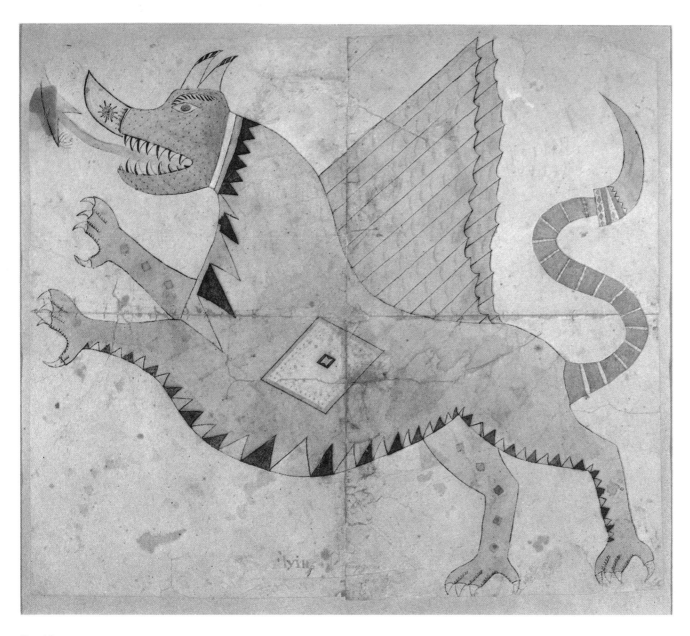

Plate 15

ANONYMOUS · *Flying "Draggon,"* n.d. · pen and water color, 11⅞ x 13¾ inches · M. and M. Karolik Collection
Museum of Fine Arts, Boston, Massachusetts

Plate 16
Emanuel LEUTZE
Head and Hands, 1857
pencil, red crayon and
Chinese white
3⅞ x 5⅜ inches (Head)
4 x 5¾ inches (Hands)
Addison Gallery of
American Art
Andover, Massachusetts

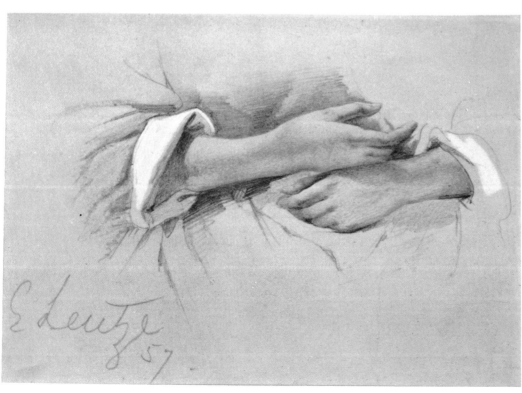

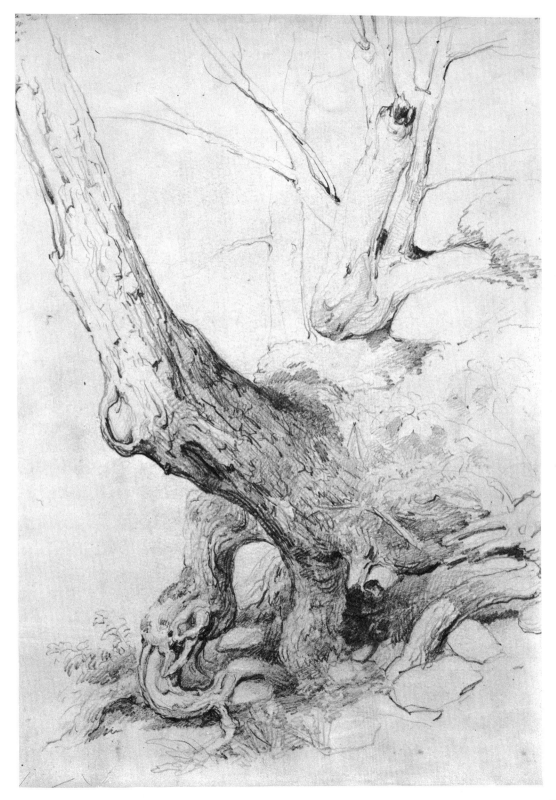

Plate 17

Asher B. DURAND
Sketch from Nature, n.d.
pencil on gray paper
14 x 10 inches
The Metropolitan Museum
of Art, New York
Gift of Mrs. John D. Sylvester
1936

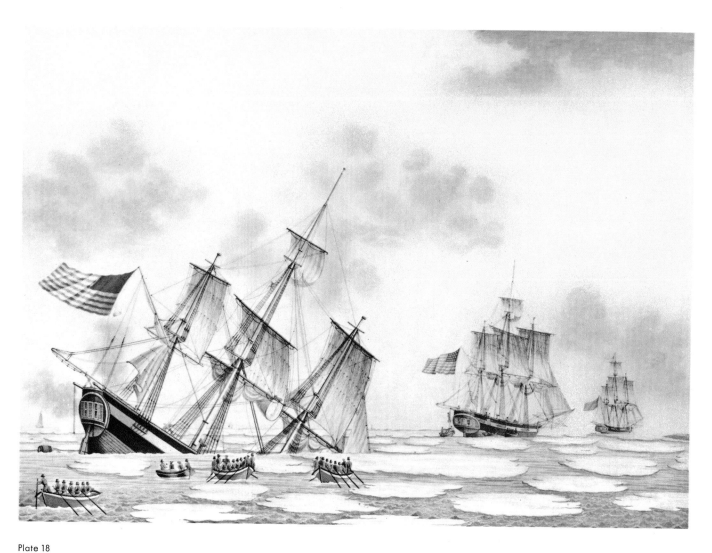

Plate 18

J. MOOY · *Ship* Janson of Providence, *sinking in an ice floe* in the Texel River, 1820 · water color, 14½ x 21 inches
Courtesy of The Peabody Museum of Salem, Massachusetts

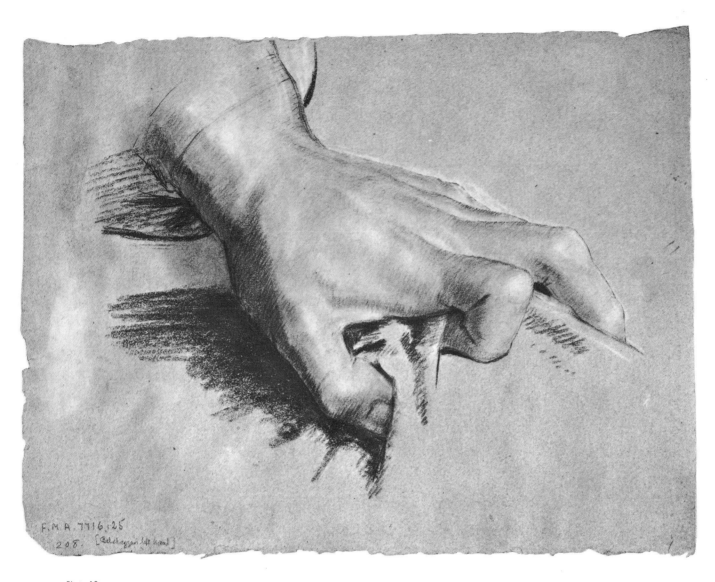

Plate 19

Washington ALLSTON • *Belshazzar's Left Hand*, n.d. • charcoal heightened with white chalk on gray, green paper
9⅛ x 12⅜ inches • Fogg Art Museum, Harvard University, Washington Allston Trust

Plate 20

William RIMMER · *Illustration for the Book of Job, n.d.* · pencil on cream paper, 11 15/16 x 14 3/8 inches · Fogg Art Museum
Harvard University, Louise E. Bettens Fund

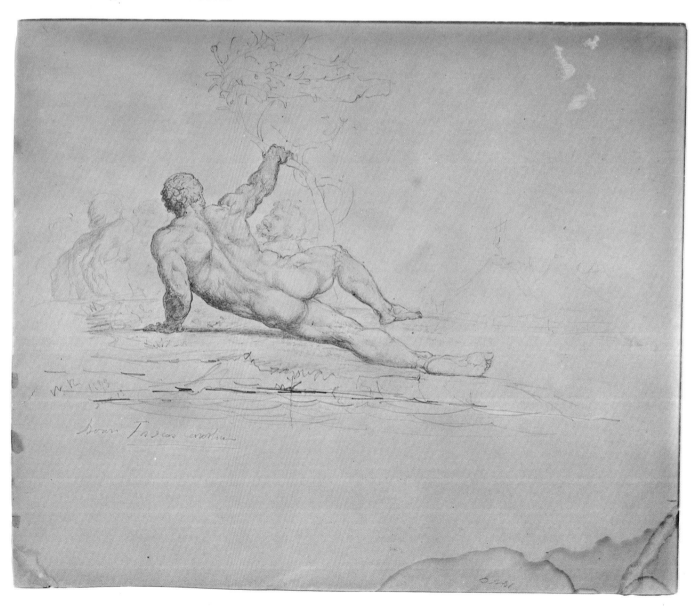

Plate 21

John VANDERLYN • *Study for Columbus Mural on the National Capitol*, n.d. • black and white chalk on brown paper
17 x 21½ inches (sight) • Sally Turner Gallery, Plainfield, New Jersey

Plate 22

Thomas DOUGHTY · *Harper's Ferry from Below*, c. 1850 · water color, 7 x 11 inches · In The Collection of The Corcoran Gallery of Art, Washington, D.C.

Plate 2

Daniel HUNTINGTON · *Sophie*, 185
black and white crayon on brown pape
12½ x 16⅛ inche
Courtesy of The Cooper Union Museu
New Yor

54

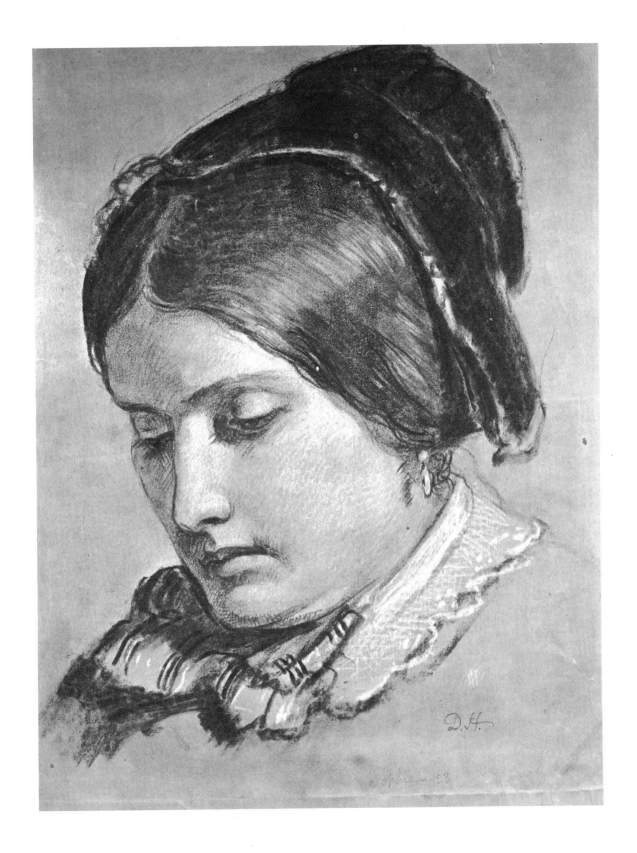

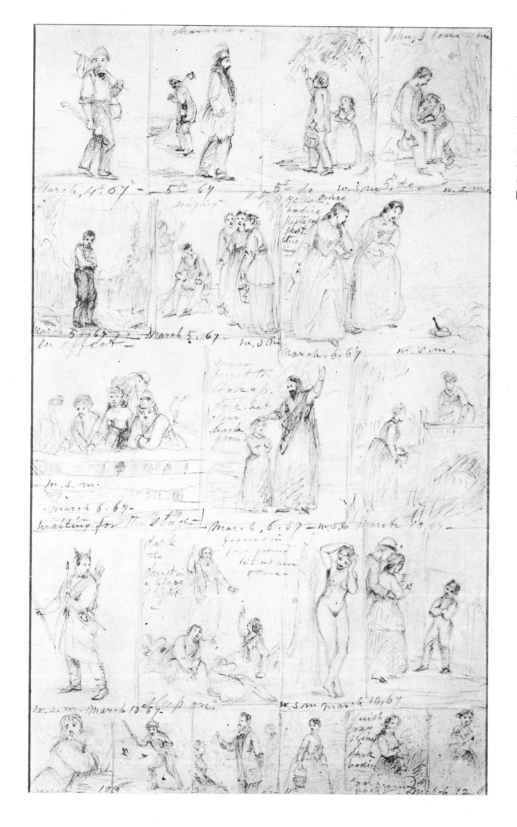

Plate 24

William Sidney MOUNT
Sheet of 20 Sketches
March 4-12, 1867
pencil, 12⅞ x 8⁄₁₆ inches
M. and M. Karolik Collection
Museum of Fine Arts
Boston, Massachusetts

Plate 25

Francis W. EDMONDS • *The Unlucky Nap*, c. 1843 (?) • water color, 6¾ x 9 inches • Philadelphia Museum of Art, Pennsylvania

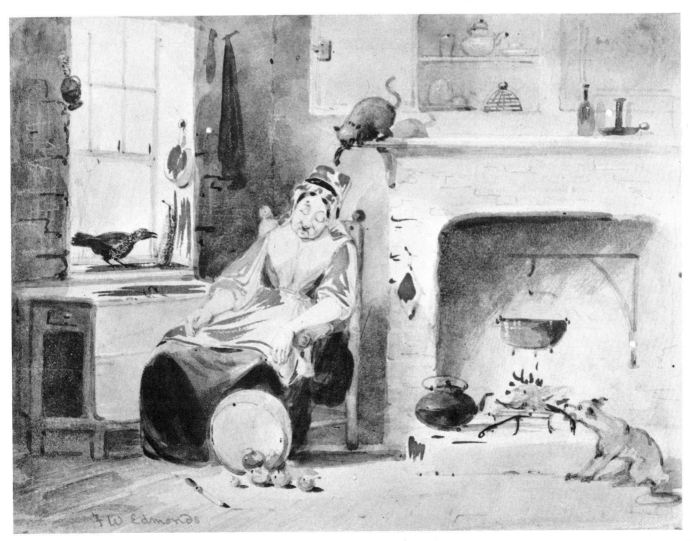

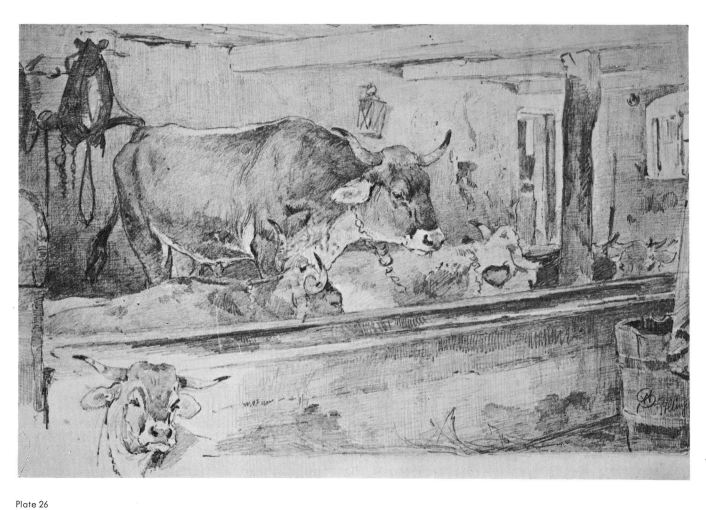

Plate 26

Walter SHIRLAW • *Cows in Stable*, 1876 • pencil on paper, 11⅜ x 17⁵⁄₁₆ inches • Courtesy of The Cooper Union Museum
New York

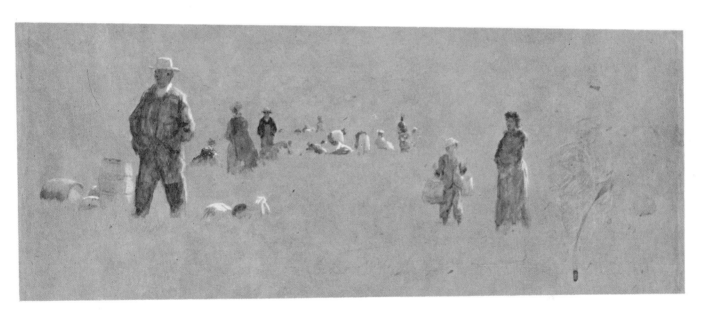

Plate 27

Eastman JOHNSON · *Berry Pickers*, c. 1870 · pencil and water color, 7¾ x 19¼ inches · Addison Gallery of American Art
Andover, Massachusetts

Plate 28

Louis MAURER · *Horse Race*, n.d. · pencil, 7½ x 13¾ inches · Museum of the City of New York

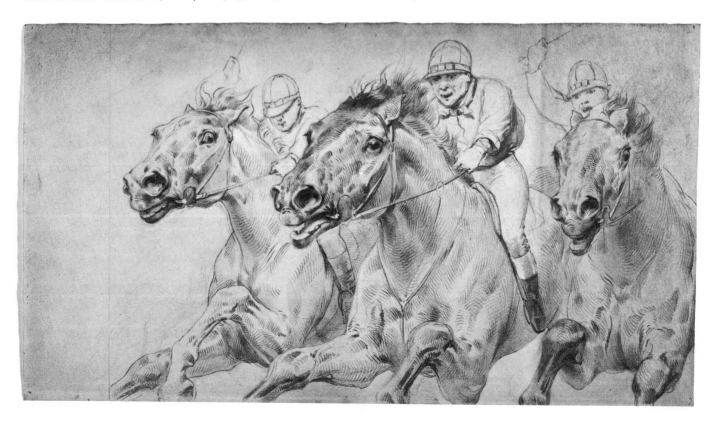

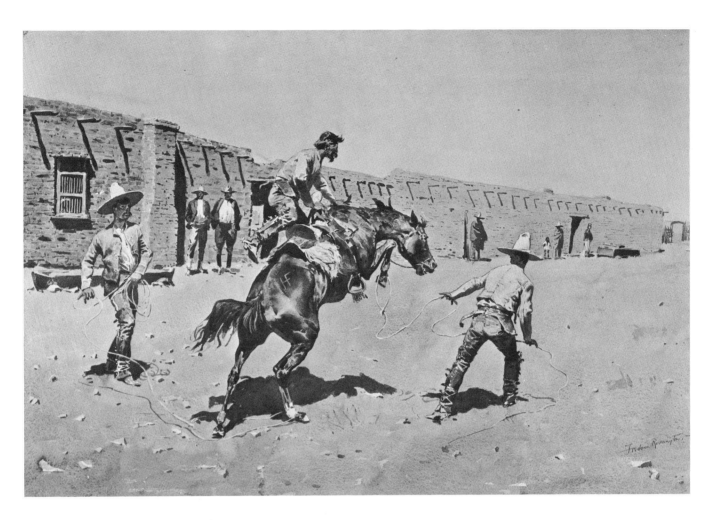

Plate 29

Frederic REMINGTON • *Mexican Vaqueros Breaking a Bronc'*, 1897 • pen and India ink wash, heightened with white
25 x 37⁷⁄₁₆ inches • Museum of Fine Arts, Boston, Massachusetts, Bequest of John T. Spaulding

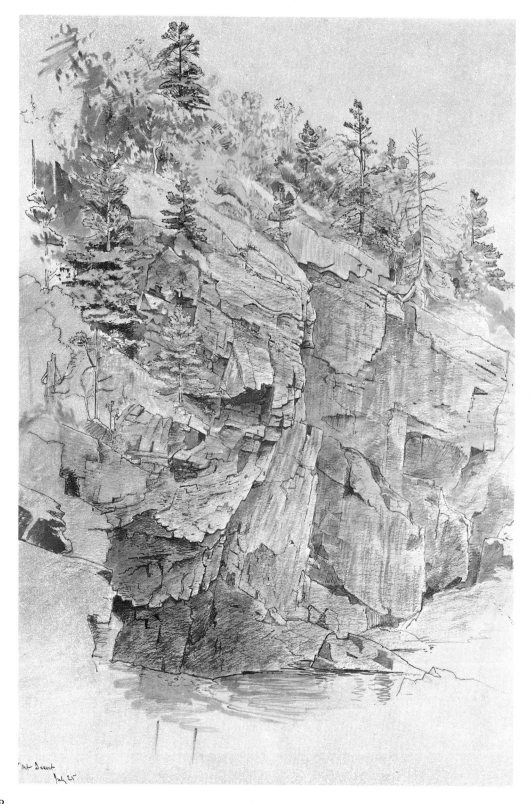

Plate 30

William Stanley HASELTINE
Mt. Desert, 1860-1865
pencil, water color and
gray wash on paper
22 x 14¾ inches
Courtesy of
The Cooper Union Museum
New York

Plate 31

Thomas MORAN · *The Mountain Range on the West side of the San Luis Valley above San Francisco*, 1883
pencil and water color, 9 x 13¾ inches · Addison Gallery of American Art, Andover, Massachusetts

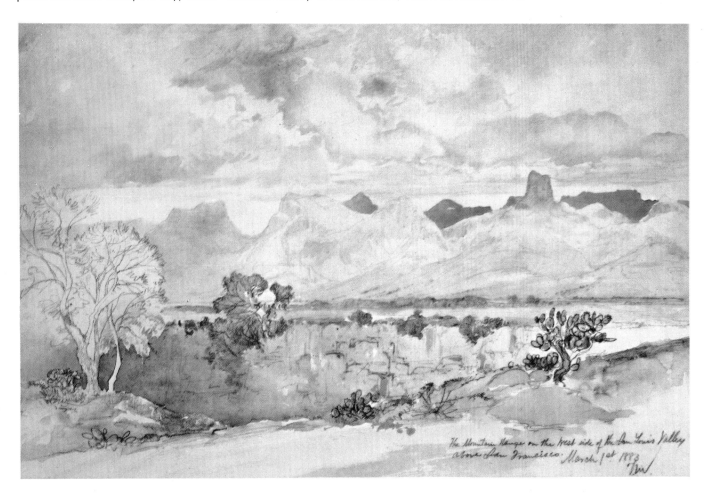

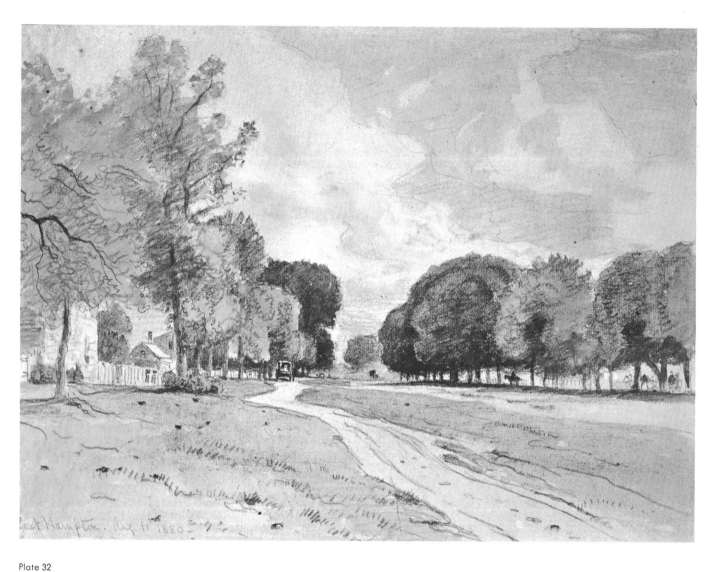

Plate 32

Samuel COLMAN • *East Hampton, Long Island,* August 1880 • black crayon, water color, white gouache on gray paper
15⁹⁄₁₆ x 18¾ inches • Courtesy of The Cooper Union Museum, New York

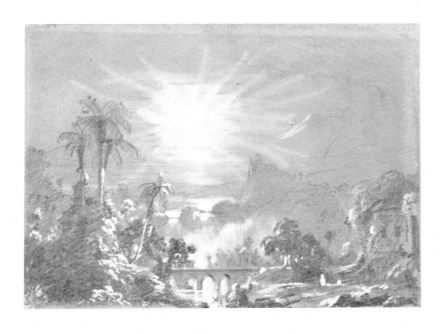

Plate 33

Frederick E. CHURCH
Romantic Landscape, n.d.
pencil and Chinese white
3 x 4¼ inches
Addison Gallery of American Art
Andover, Massachusetts

Plate 34

Thomas EAKINS • *Study for the Portrait of*
Professor Henry A. Rowland, c. 1897
oil, 12 x 9 inches
Addison Gallery of American Art
Andover, Massachusetts

Plate 35

Winslow HOMER • *Waiting for a Bite*, c. 1874 • pencil and water color, 7¼ x 13½ inches • Private Collection
Dedham, Massachusetts

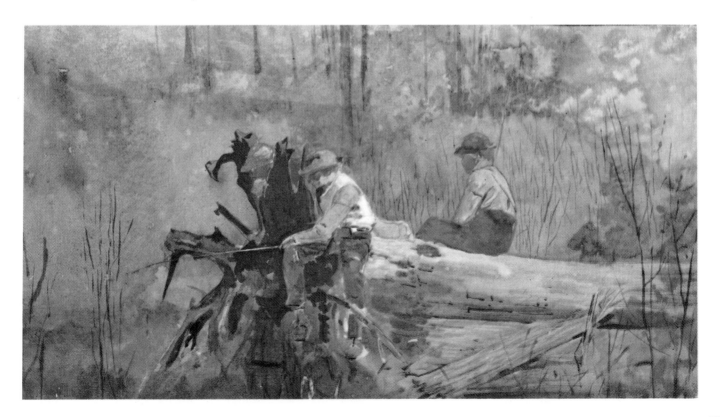

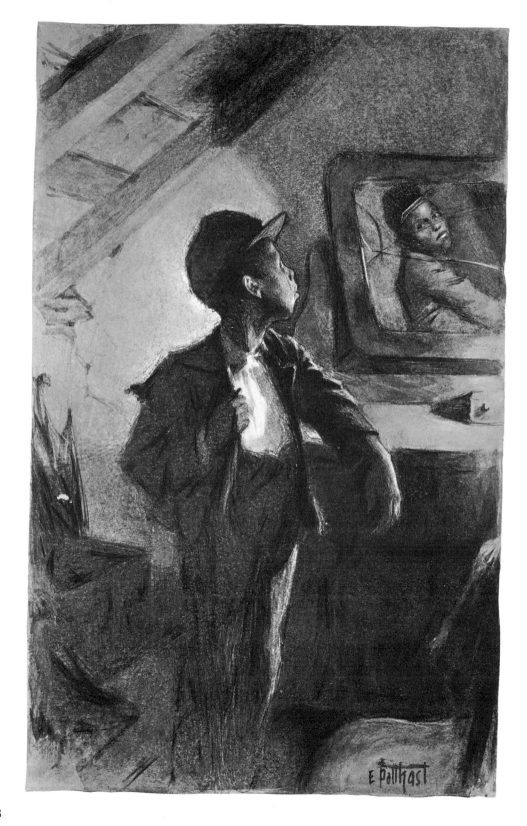

Plate 36

Edward H. POTTHAST
George Washington Jones, n.d.
charcoal with Chinese white
19¾ × 14¾ inches
The Brooklyn Museum
New York

Plate 37

Daniel GARBER • *Old House*, c. 1940 • pencil and charcoal, 18 x 24 inches • In The Collection of The Corcoran Gallery of Art Washington, D.C.

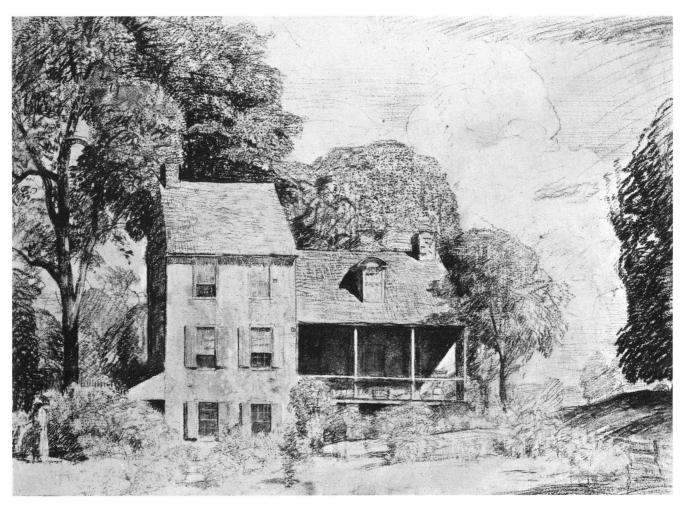

Plate 38

Elihu VEDDER · *Drapery for Figure of Fortune*, c. 1890 · black crayon, pencil, white and yellow chalks on purple paper
16¹³⁄₁₆ x 11¹³⁄₁₆ inches · Courtesy of The Cooper Union Museum, New York

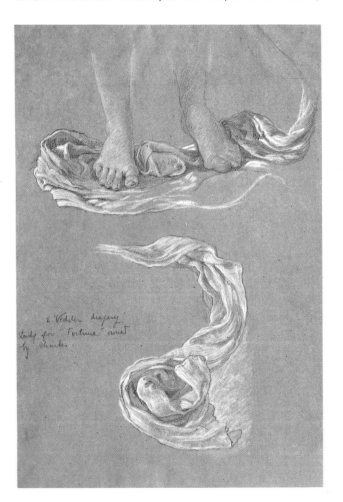 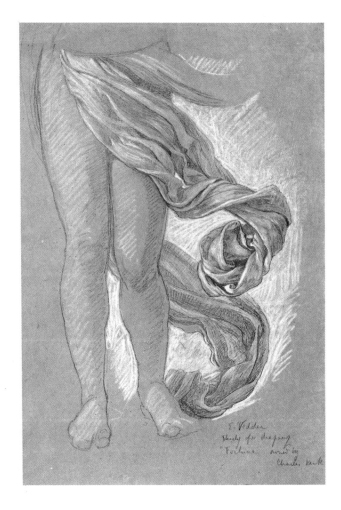

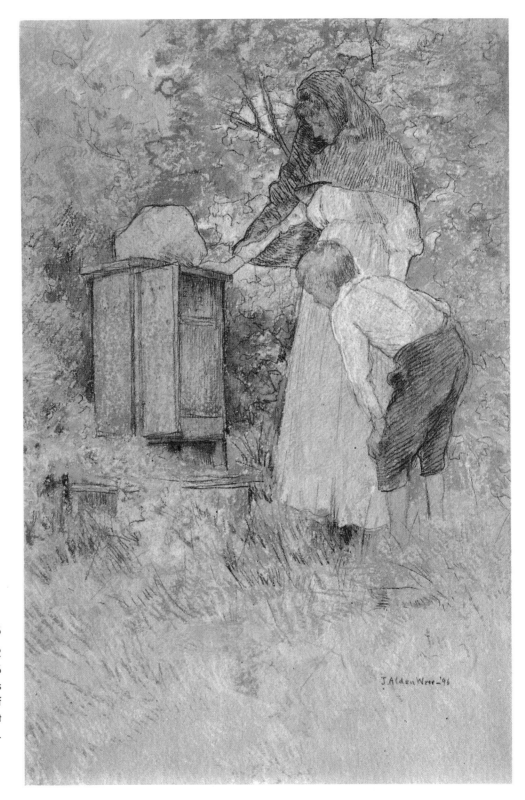

Plate 39
J. Alden WEIR
Watching the Bees, 1896
pastel, 13¼ x 8¾ inches
In The Collection of
The Corcoran Gallery of Art
Washington, D.C.

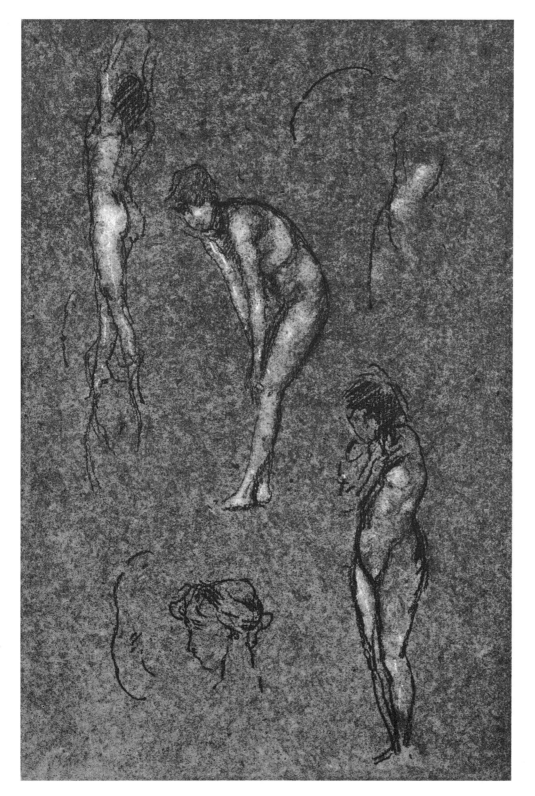

Plate 40

James A. McNeill WHISTLER
Sketches of the Figure, Tilly, n.d.
black and brown crayon and
white chalk on brown paper
11¾ x 7¾ inches
Fogg Art Museum
Harvard University
Gift of Philip Hofer

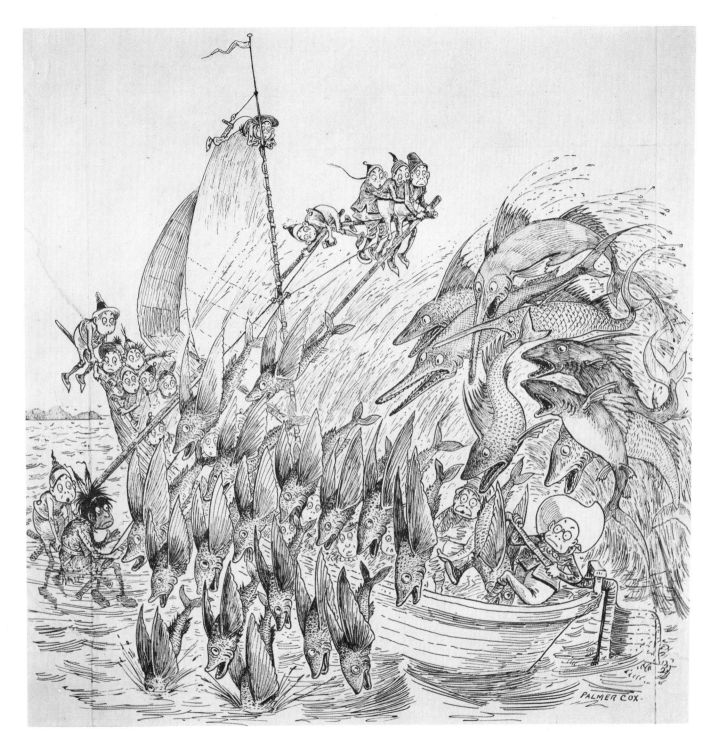

Plate 41

Palmer COX • *Samar* (Brownies and Fish), 1904 • pencil, pen and black ink on white paper, 13¹³⁄₁₆ x 11⅝ inches
Courtesy of The Cooper Union Museum, New York

Plate 42

Mary CASSATT
Mother and Child, n.d.
pencil and pastel, 8 x 4⅜ inches
Addison Gallery of American Art
Andover, Massachusetts

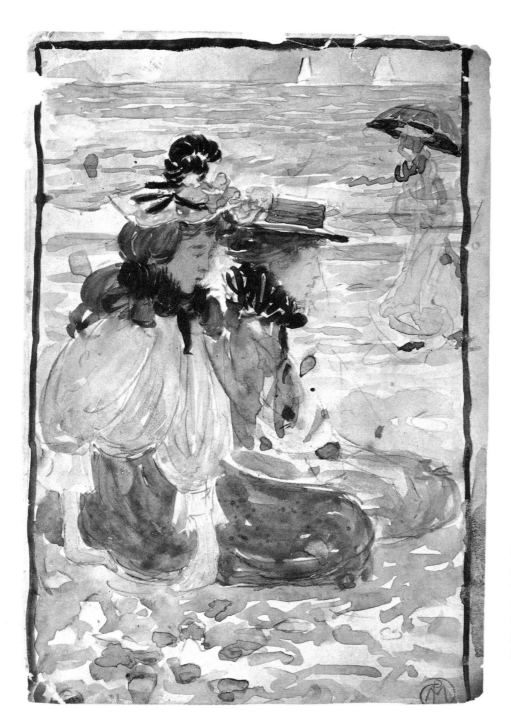

Plate 43

Maurice PRENDERGAST
Two Girls Sitting on the Beach
(Page 3 from Sketchbook, verso), 1899
water color, 7 x 5 inches
Museum of Fine Arts
Boston, Massachusetts

Plate 44

Thomas NAST • *Tammany Tiger*, 1872 • crayon, 14½ x 21¼ inches • Addison Gallery of American Art, Andover, Massachusetts

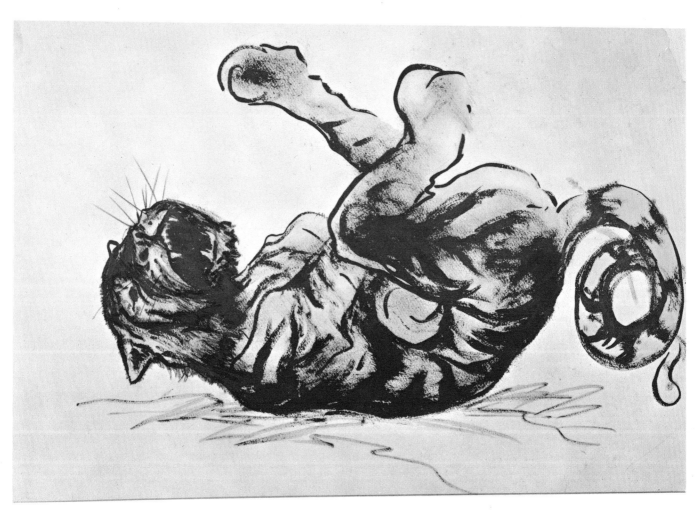

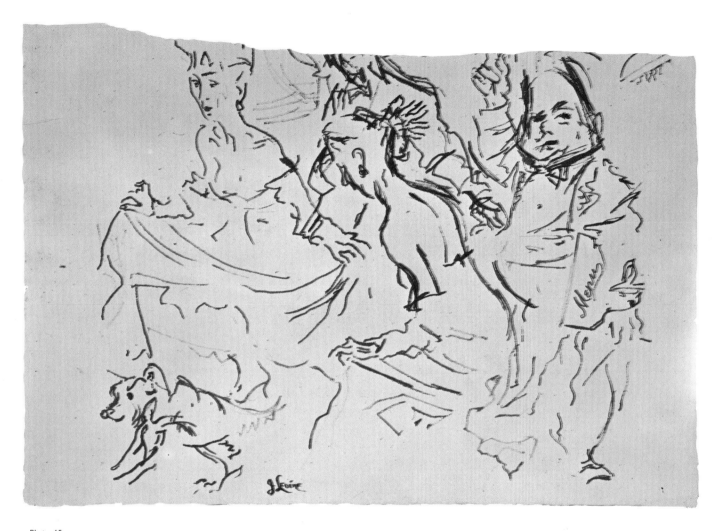

Plate 45

Jack LEVINE • *Study for Reception in Miami*, 1947 • brown ink on gray paper, 14½ x 22⅝ inches • Fogg Art Museum
Harvard University, Meta and Paul J. Sachs Collection

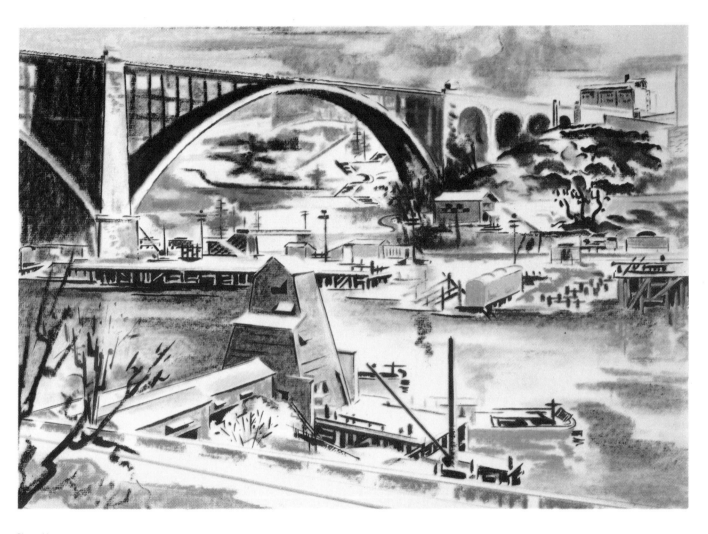

Plate 46

Preston DICKINSON • *Harlem River*, n.d. • pastel and ink, 14¾ x 21¼ inches • Whitney Museum of American Art, New York

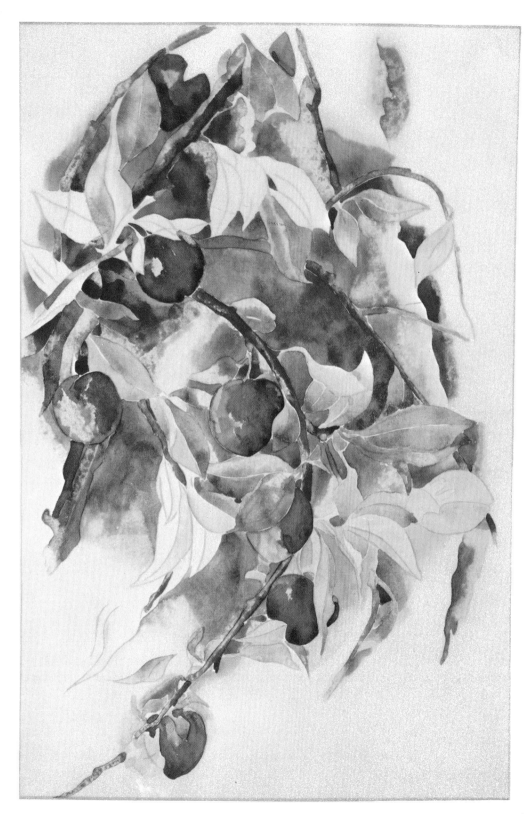

Plate 47
Charles DEMUTH
Plums, 1925
pencil and water color
$17\frac{1}{2}$ x $11\frac{1}{2}$ inches
Addison Gallery of
American Art
Andover, Massachusetts

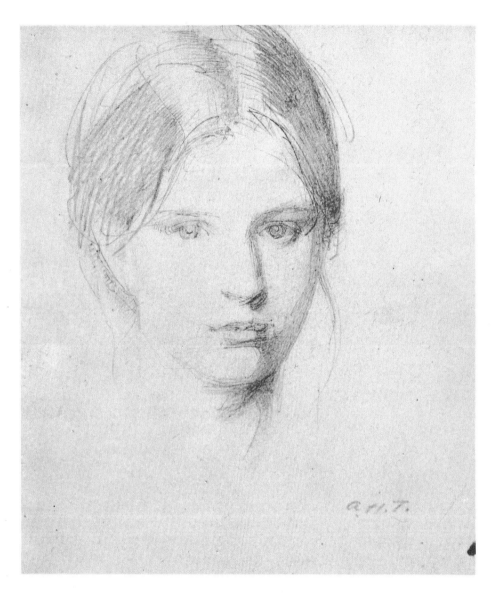

Plate 48

Abbott H. THAYER · *Portrait of the Artist's Daughter, Mary*, n.d. · pencil, 8¾ x 7½ inches
National Collection of Fine Arts, Smithsonian Institution, Washington, D.C.

Plate 4

Elie NADELMAN
Head and Neck, c. 1904-1907
pen and black ink, 12 x 6 inches
Present whereabouts unknown

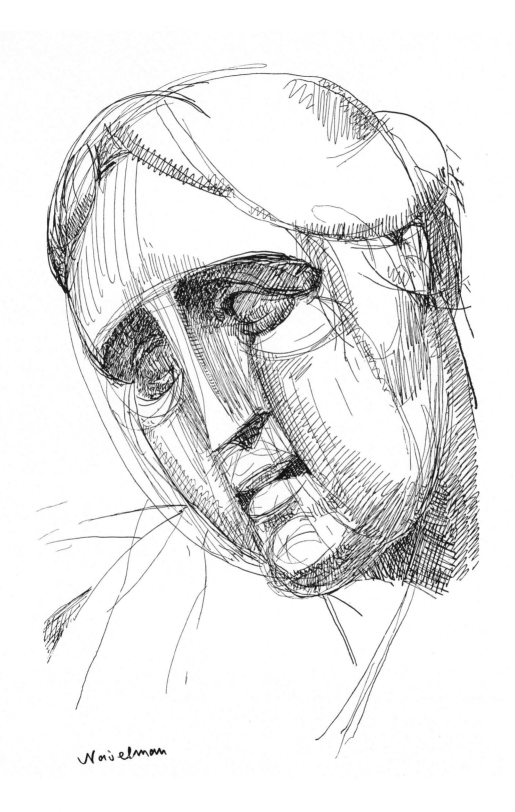

Noivelman

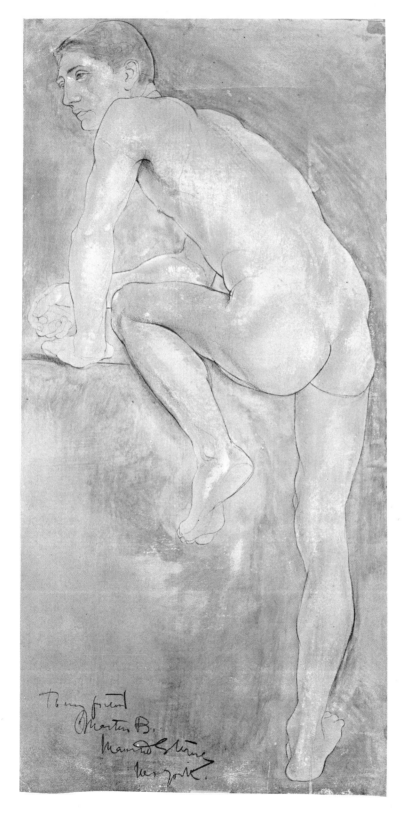

Plate 50

Maurice STERNE
Standing Male Nude, c. 1920
pencil, pen and ink with blue and tan
water color, 24 x 11⅞ inches
Courtesy of The Cooper Union
Museum, New York

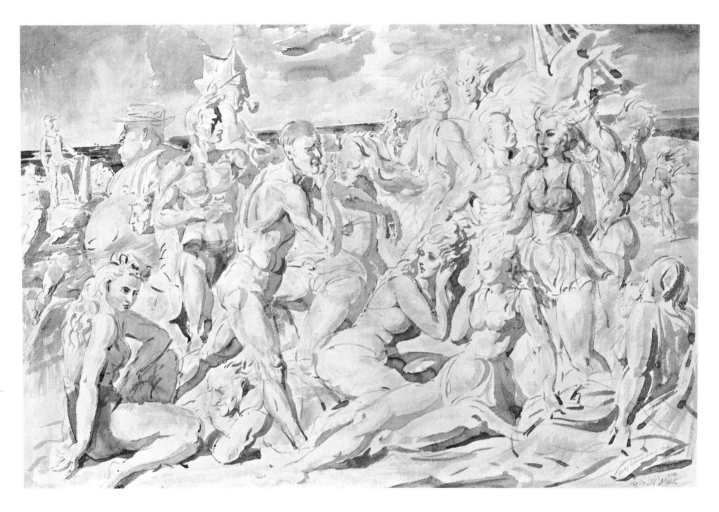

Plate 51

Reginald MARSH • *Coney Island Beach*, 1946 • Chinese ink, 27 x 40 inches • Rehn Gallery, New York

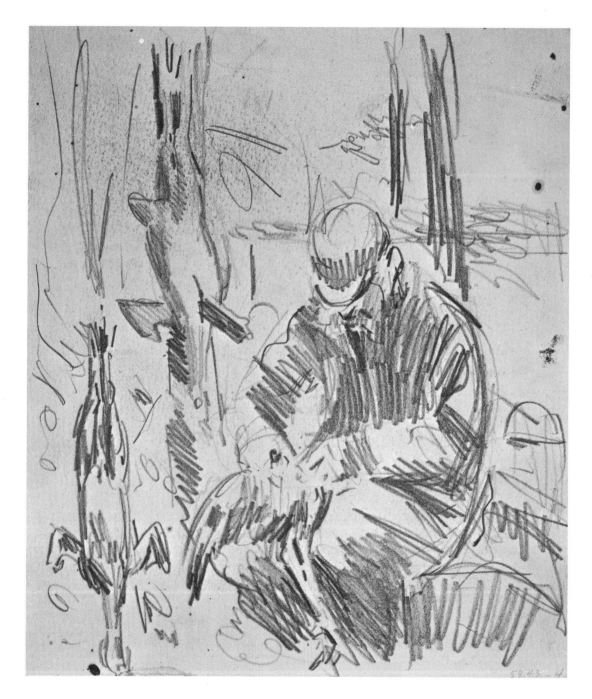

Plate 52

George B. LUKS
Seated Man With Game, n
pencil, 8⅞ x 7³⁄₁₆ inches
The Brooklyn Museum
New York

Plate
Emil GANSO • *Seated Nude,* 193
crayon and chalk, 19½ x 14½ inche
Whitney Museum of American Art, New Yor

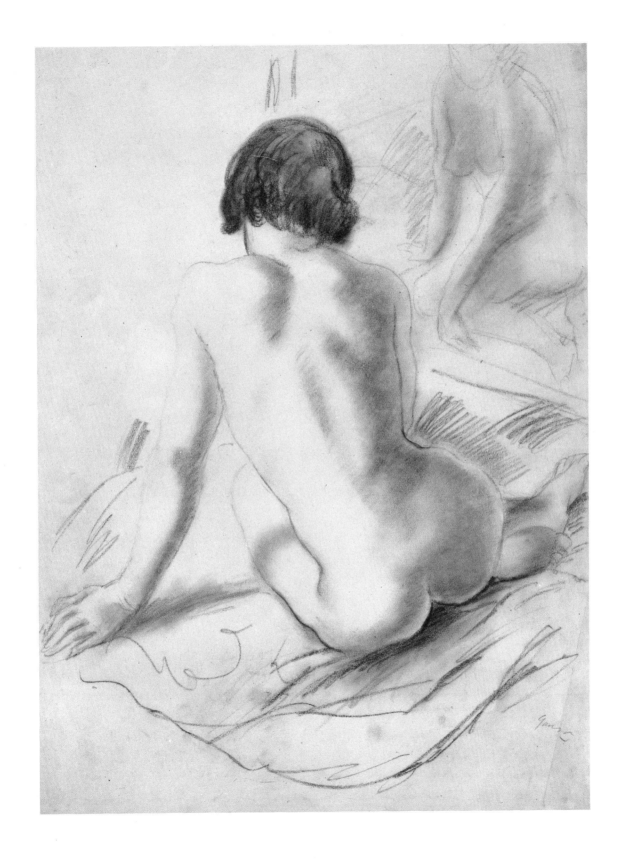

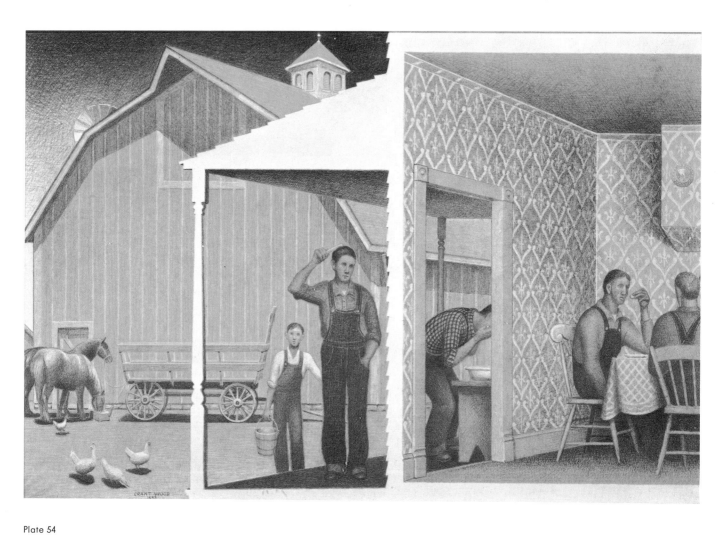

Plate 54

Grant WOOD · *Dinner for Threshers* (Study for the left section of the painting), 1933 · pencil, 17¾ x 26¾ inches
Whitney Museum of American Art, New York

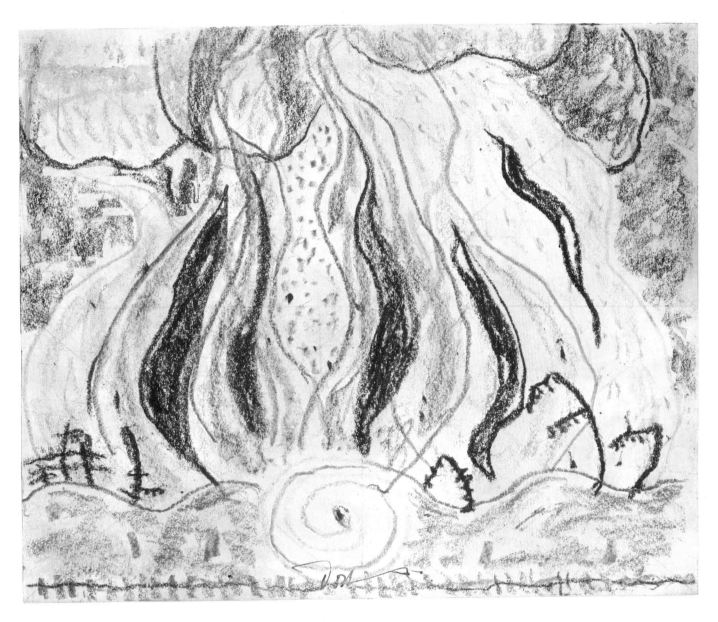

Plate 55

Arthur DOVE · *Fire in a Sauerkraut Factory*, 1936 · color crayon drawing, 8½ x 10½ inches · Courtesy of Downtown Gallery
New York

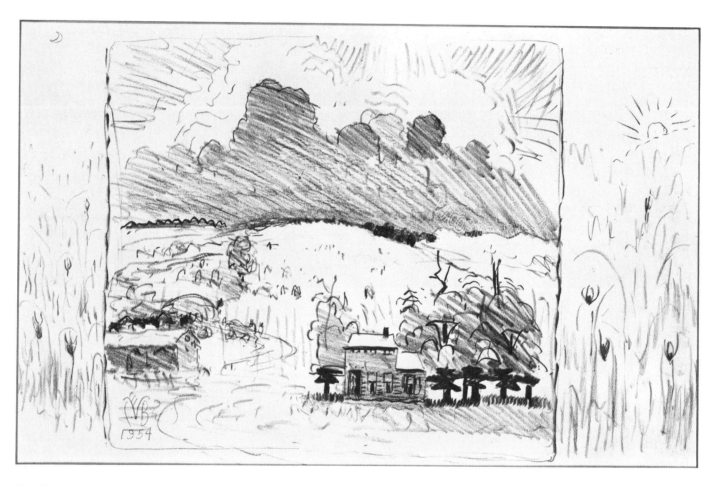

Plate 56

Charles BURCHFIELD · *Study for lightning at dusk, 1954* · conté crayon, 11 x 17 inches · Rehn Gallery, New York

Plate 5

Yasuo KUNIYOSHI · *Fisherman, 1921* · in
13¾ x 9⅛ inches · Daniel Fraad, New Yor

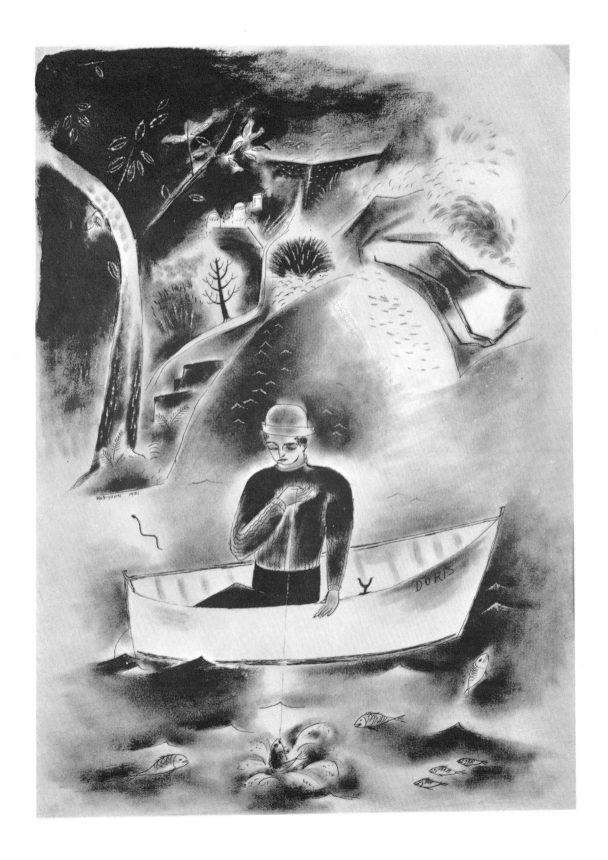

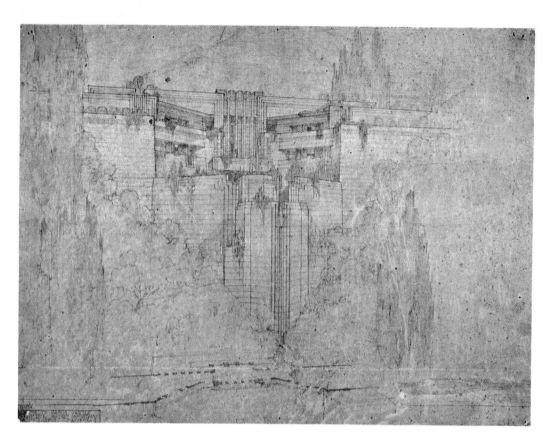

Plate 58

Frank Lloyd WRIGHT
*Rendering for the Doheny Ranc
Project,* Sierra Madre Mountair
California, 1921
pencil and colored pencil on
tracing paper mounted on boar
17 x 21⅝ inches
Mrs. Frank Lloyd Wright
Scottsdale, Arizona

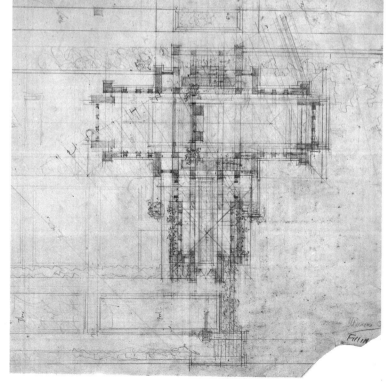

Plate 59

Frank Lloyd WRIGHT
Plan of Ullman House, 1904
pencil on tracing paper
12¾ x 16⅞ inches
Mrs. Frank Lloyd Wright,
Scottsdale, Arizona

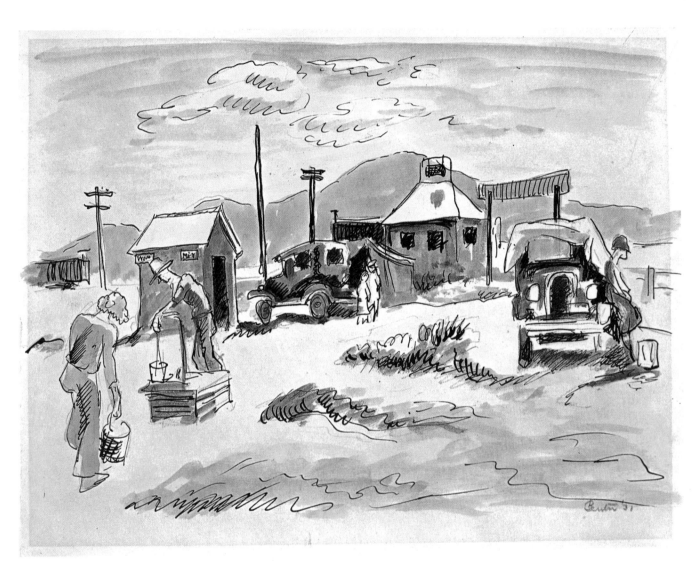

Plate 60

Thomas Hart BENTON · *Western Tourist Camp*, 1931 · pen and ink with wash, 8¾ x 11¾ inches · Allen Memorial Art Museum
Oberlin College

Plate 61

Joseph STELLA • *Pittsburgh Winter*, 1908 • charcoal, 17¾ x 24 inches • Daniel Fraad, New York

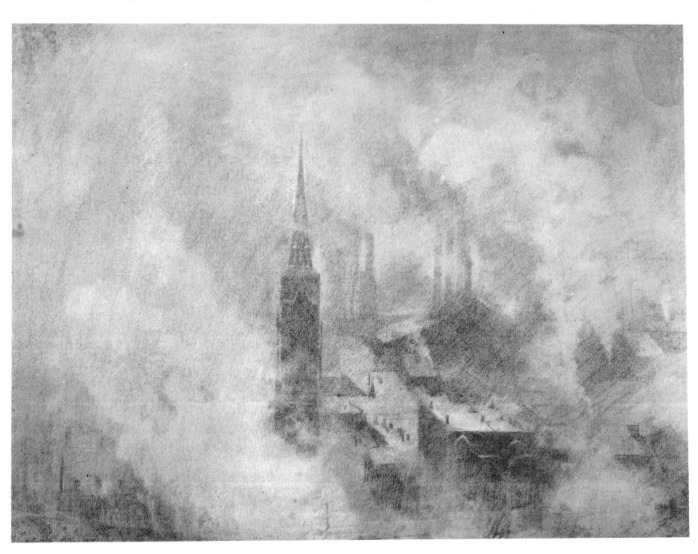

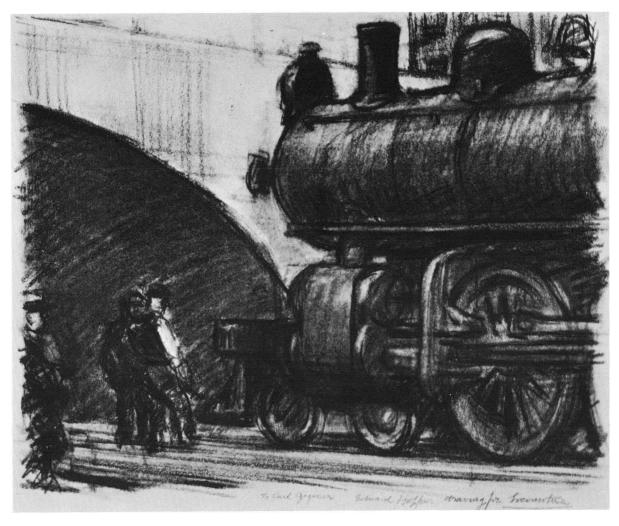

Plate 62

Edward HOPPER • *Locomotive, c. 1923* • charcoal drawing, 8¼ x 10¼ inches • Philadelphia Museum of Art
Pennsylvania

Plate 63

Lyonel FEININGER • *Blue Barque,* Oct. 1, 1944 • pen and water color, 12⅝ x 19 inches • Museum of Fine Arts, Boston, Massachusetts

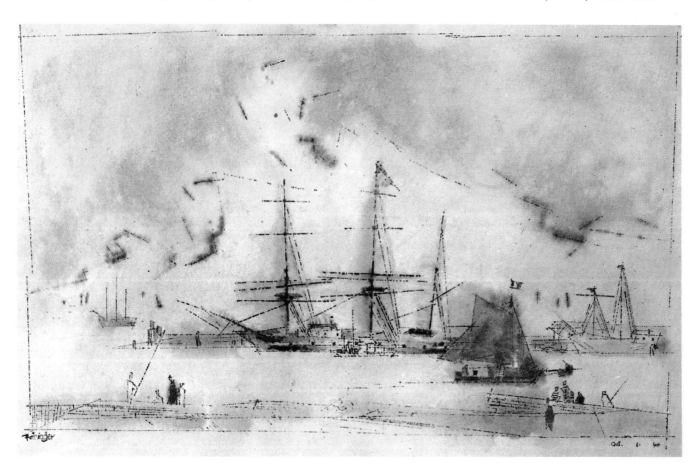

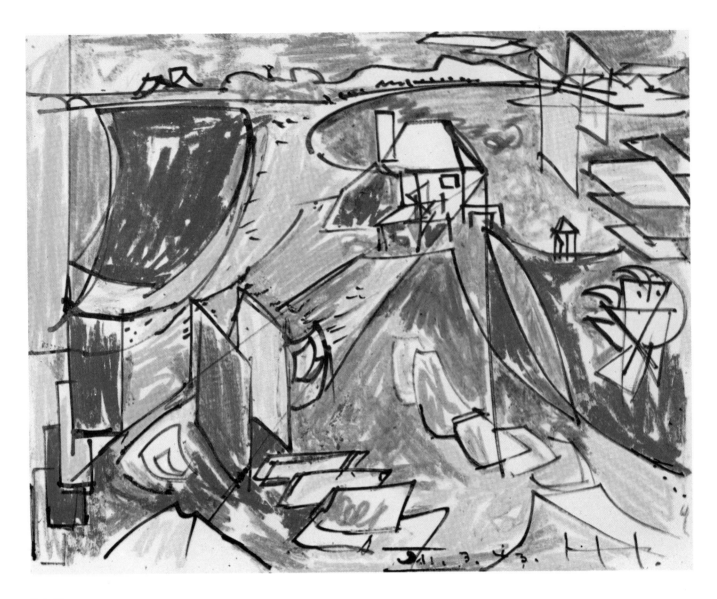

Plate 64

Hans HOFMANN · *Provincetown,* 1943 · ink and colored crayon, 11 x 14 inches · Addison Gallery of American Art
Andover, Massachusetts

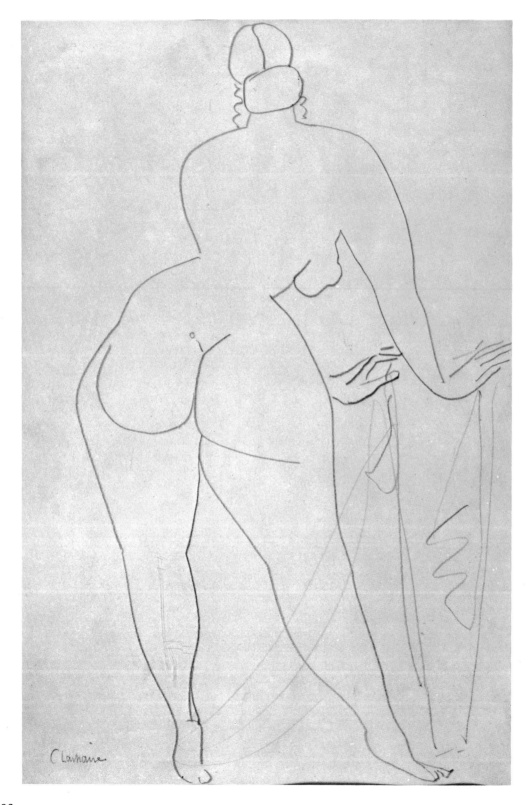

Plate 65

Gaston LACHAISE
Standing Nude
Between 1922-32
pencil, 17¾ x 11¾ inches
Whitney Museum of
American Art, New York

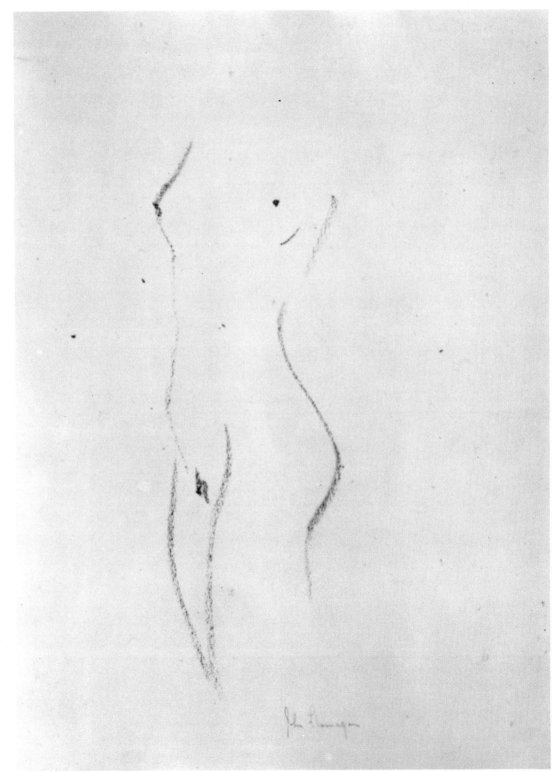

Plate 66
John B. FLANNAGAN
Nude, Profile, c. 1936
crayon, 12½ x 3⅞ inches
Philadelphia Museum of Art
Pennsylvania

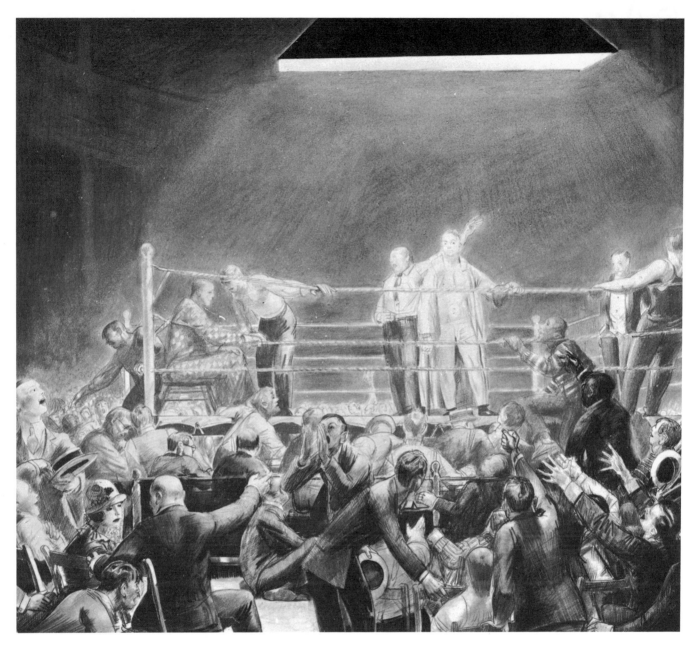

Plate 67

George BELLOWS • *Ringside Seats*, 1924 • pencil with black and blue crayon on white paper, 22⅝ x 25⅞ inches
Fogg Art Museum, Harvard University, Grenville L. Winthrop Bequest

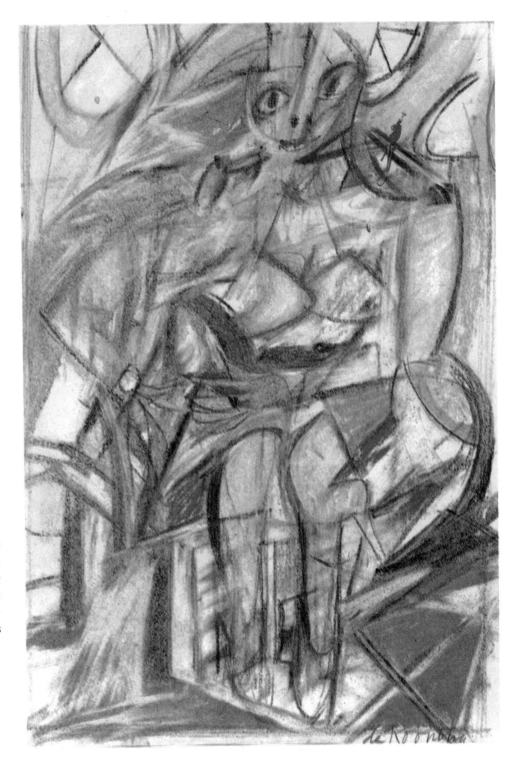

Plate 68
Willem de KOONING
Seated Woman #1, 1952
pastel on paper, 11⅛ x 7½ inches
Mr. & Mrs. Sherman H. Starr
Lexington, Massachusetts

Plate 69

Joseph GLASCO
Big Sitting Cat, 1949
pen and ink, 40 x 26⅛ inches
Collection, The Museum of
Modern Art, New York
Katharine Cornell Fund

Plate 70

George SKLAR
Racoon, 1947
wash drawing
10¾ x 9½ inches
Philadelphia Museum of Art
Pennsylvania

george ðehn-47

101

Plate 71

John MARIN
Abstraction, 1921
water color, 16⅞ x 14⅛ inches
The Metropolitan Museum of Art
New York
The Alfred Stieglitz Collection, 1949

Plate 72

John MARIN
River Movement, Paris, 1909
water color, 13⅜ x 16¼ inches
The Metropolitan Museum of Art
New York
The Alfred Stieglitz Collection
1949

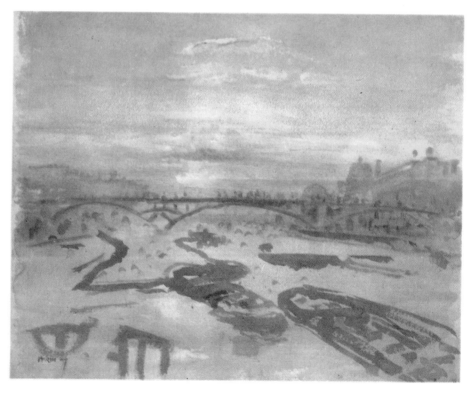

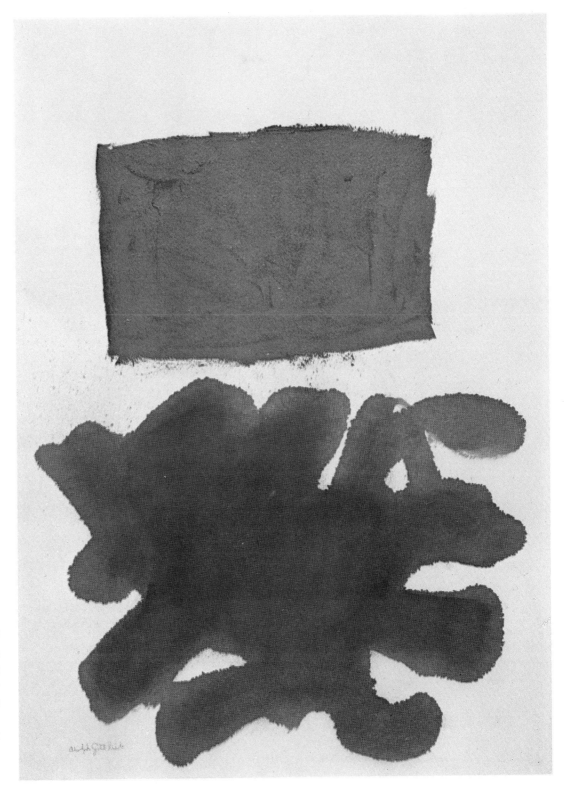

Plate 73
Adolph GOTTLIEB
Green Rectangle, 1960
ink and oil on paper
30⅝ x 22¼ inches
The Artist's Collection
New York

Plate 74

Charles SHEELER · *Self Portrait*, 1923 · black conté crayon, 19¾ x 25¾ inches · Collection, The Museum of Modern Art, New York
Gift of Mrs. John D. Rockefeller, Jr.

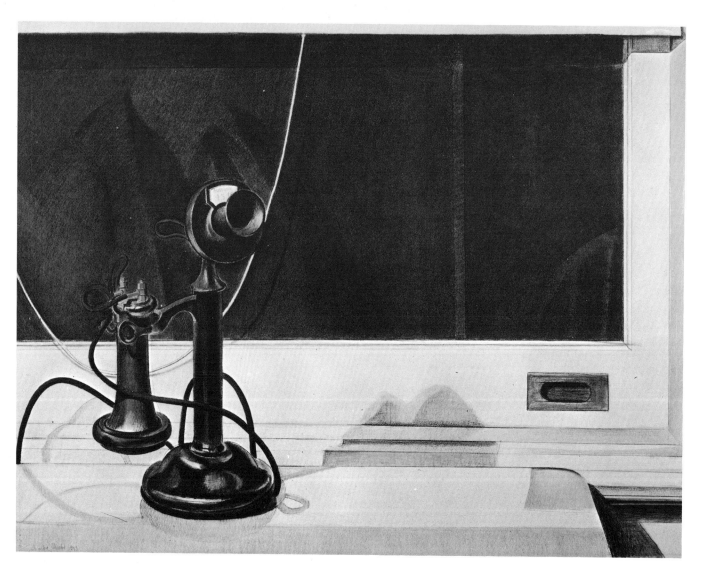

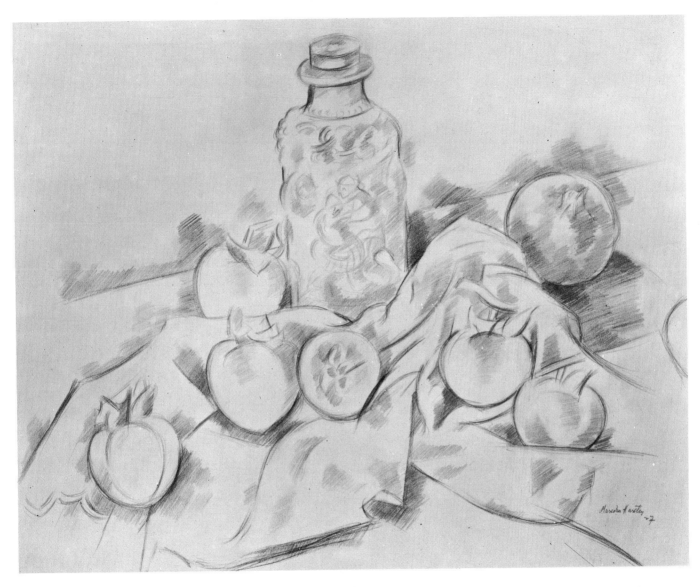

Plate 75

Marsden HARTLEY · *Still Life*, 1927 · pencil on paper, 18⅛ x 23⅞ inches · Mrs. Michael Heron, Denver, Colorado

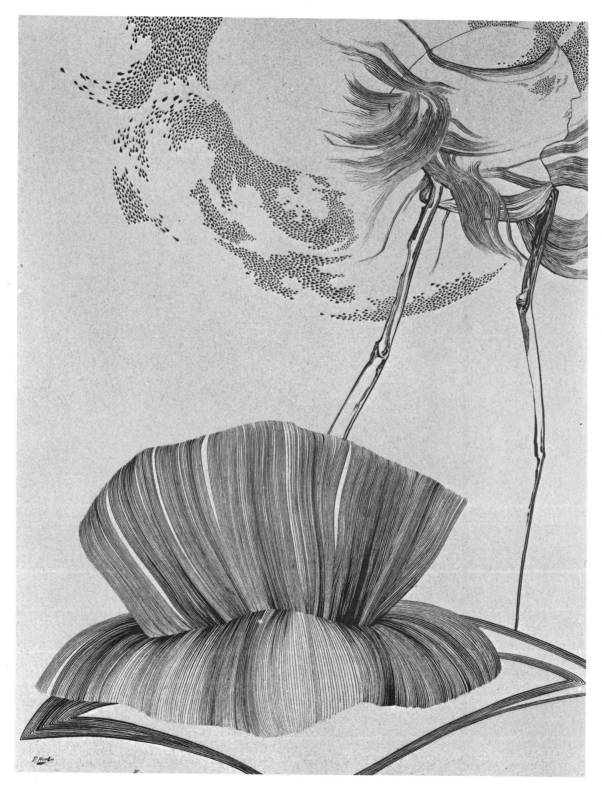

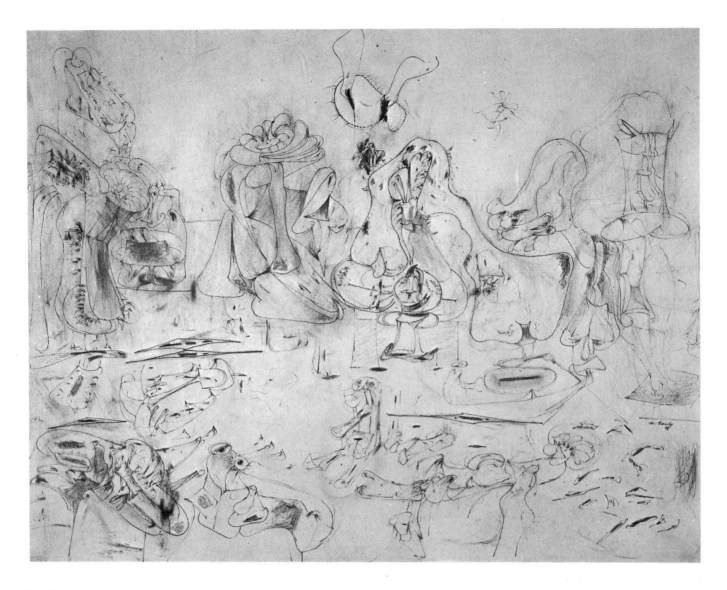

Plate 77

Arshile GORKY • Drawing, *Study for "Summation,"* 1946 • pencil and crayon, 18½ x 24½ inches
Whitney Museum of American Art, New York, Gift of Mr. and Mrs. Wolfgang S. Schwabacher

Plate 76
Dorothy HOOD • *Walking Away from the Sun*
1959 • ink drawing, 25⅝ x 19⁹⁄₁₆ inches
Philadelphia Museum of Art, Pennsylvania

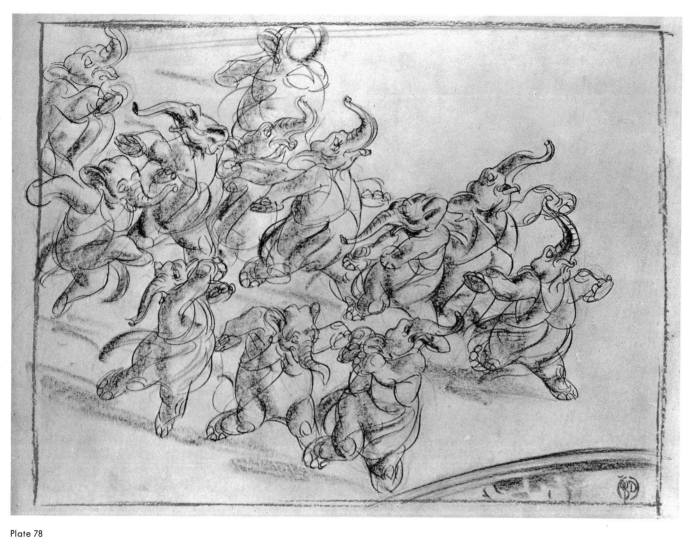

Plate 78

Walt DISNEY Studio · *Fantasia, Elephant Ballet,* c. 1939 · ink and pencil, 9⅞ x 11⅞ inches · Walt Disney Studio, California
© 1939 Walt Disney Productions

Plate 79

Alexander CALDER · Cowboy, 1932 · ink drawing, 9⅛ x 18⅝ inches · Philadelphia Museum of Art, Pennsylvania

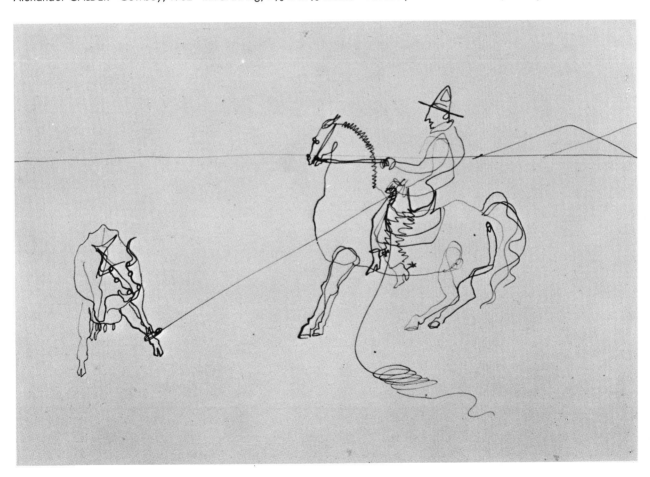

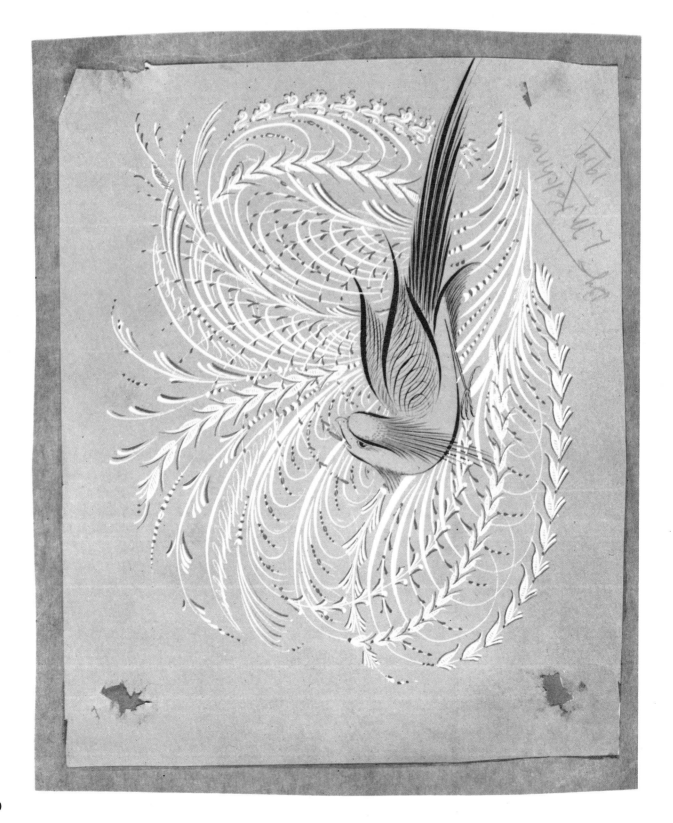

110

Plate 81

Stuart DAVIS • *Windshield Mirror*, 1932 • gouache drawing, 15⅛ x 25 inches • Philadelphia Museum of Art, Pennsylvania

Plate 80

L. M. KELCHNER • *Bird*, 1919 • pen and four inks
9⅝ x 7⅞ inches • Warren T. Johnson
Peterboro, New Hampshire

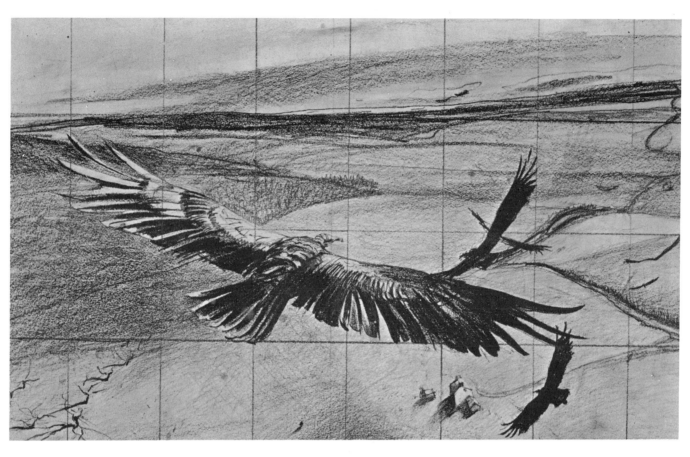

Plate 82

Andrew N. WYETH · *Buzzard*, 1942 (?) · graphite on bristol board, 12 x 19½ inches · Museum of Fine Arts, Boston, Massachusetts
Bequest of Maxim Karolik

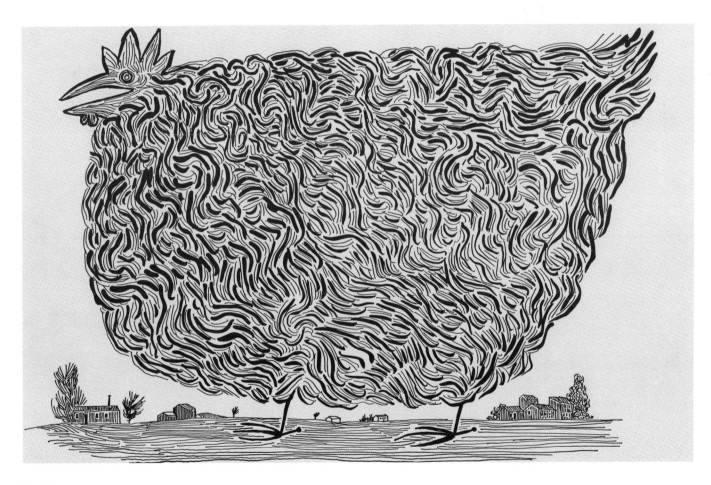

Plate 83

Saul STEINBERG • *Hen*, 1945 • pen and brush and ink, 14½ x 23⅛ inches • Collection, The Museum of Modern Art, New York
Purchase

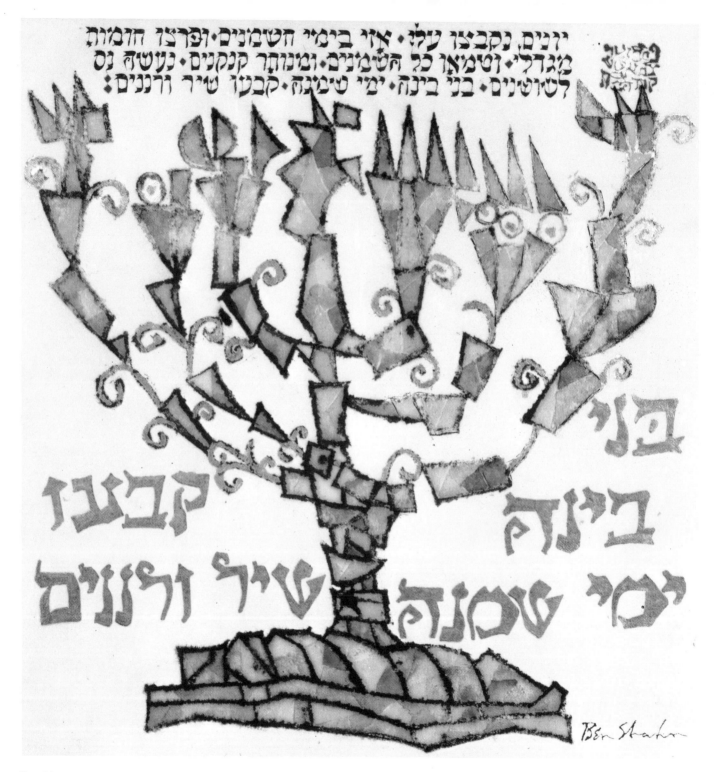

Plate 84

Ben SHAHN · *Chanukah*, 1961 · water color and gold leaf on paper, 20 x 19 inches · Mr. and Mrs. Lawrence A. Fleischman
Detroit, Michigan

114

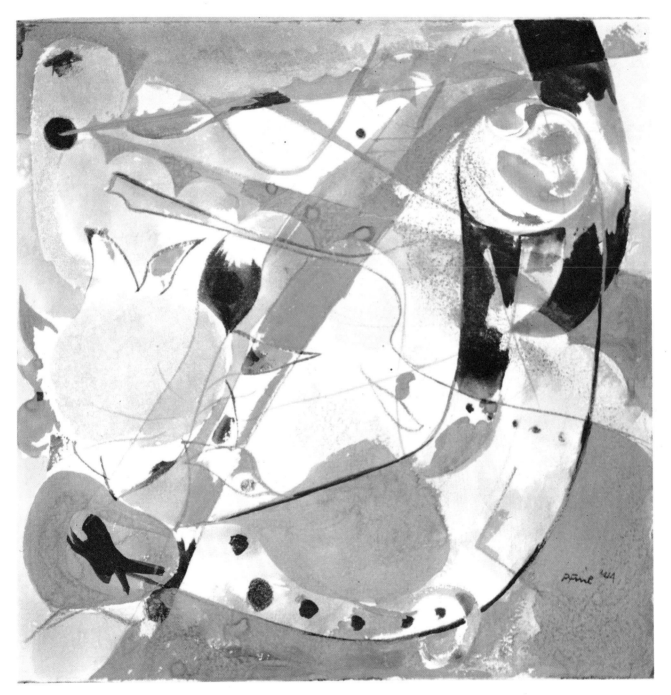

Plate 85

Perle FINE · *In the Beginning*, 1949 · pencil and water color, 6 x 6 inches · Private Collection, Andover, Massachusetts

Plate 86

George HERRIMAN • *Krazy Kat* (detail), 1936 • pen and ink, 24⅞ x 19⅜ inches • The Brooklyn Museum, New York
© King Features Syndicate, Inc., 1964

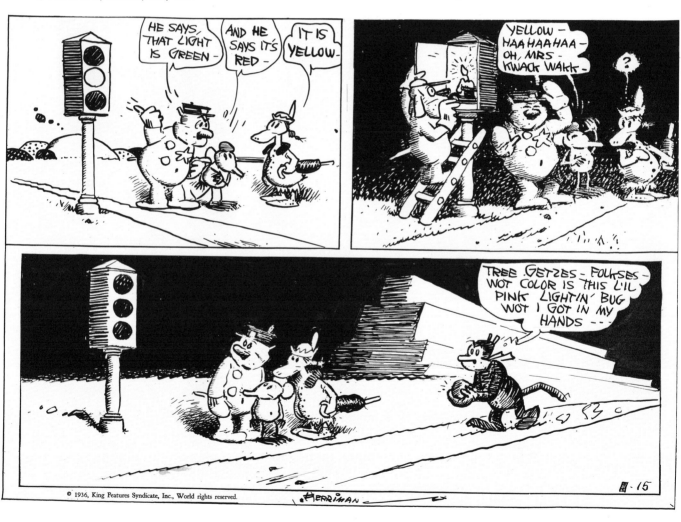

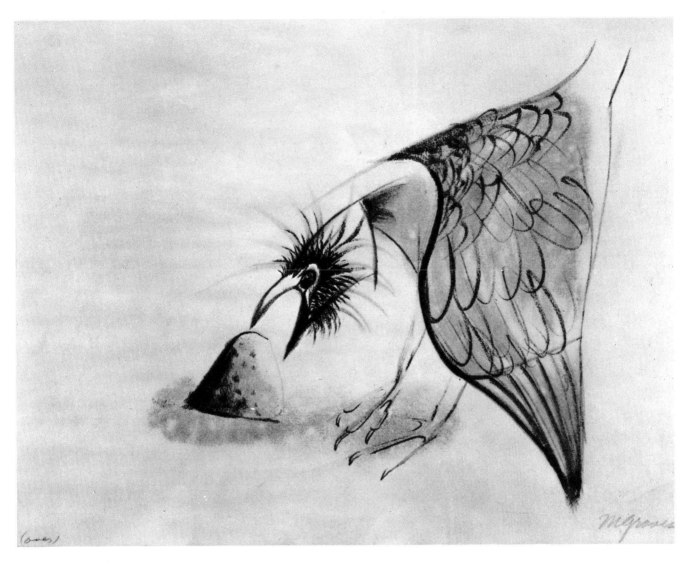

Plate 87

Morris GRAVES • *Bird Attacking Stone*, n.d. • brush, 10⅜ x 13⅜ inches • Museum of Fine Arts, Boston, Massachusetts

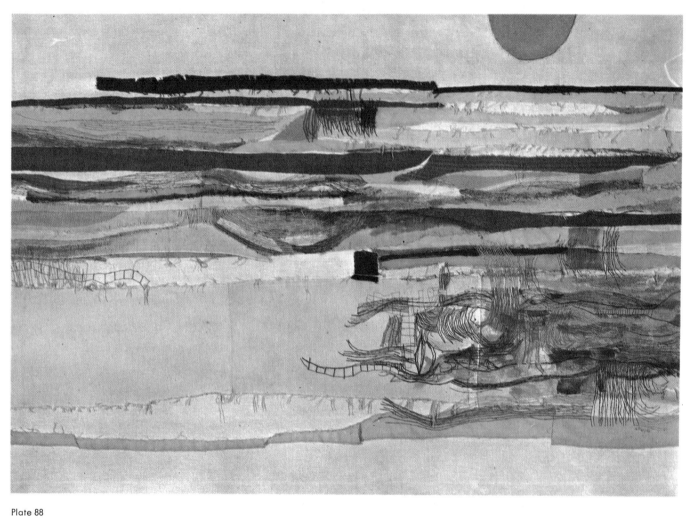

Plate 88

Marilyn R. PAPPAS • *Skaket Beach*, 1961 • appliqué and stitchery, 47 x 67 inches • Mr. and Mrs. A. J. Wadman
Silver Spring, Maryland

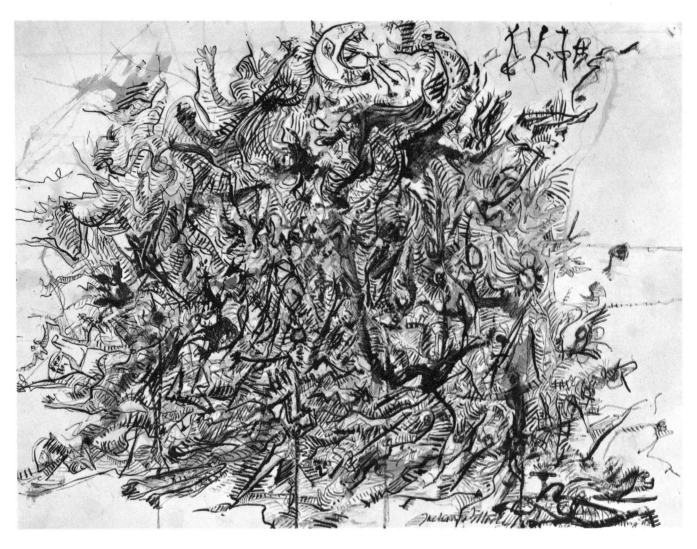

Plate 89

Jackson POLLOCK · *Untitled*, c. 1944-45 · gouache, 22½ x 15½ inches · Mrs. Kay Hillman, New York

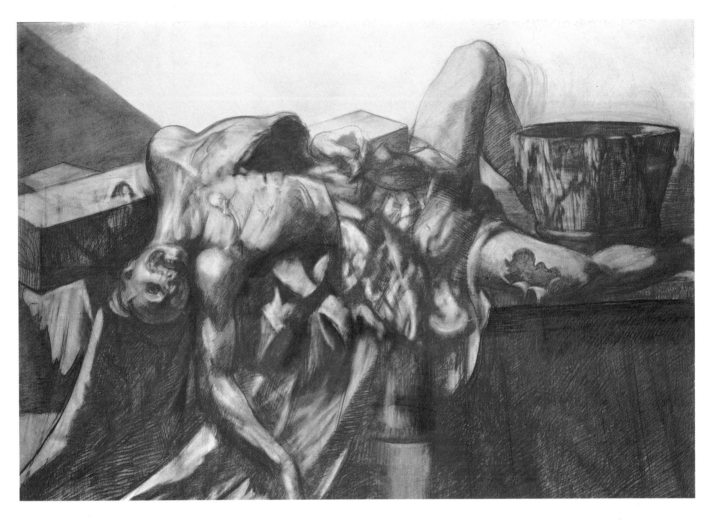

Plate 90

Hyman BLOOM • *Cadaver No. 2, 1952* • sanguine crayon, 41½ x 58¾ inches • Collection Downtown Gallery, New York

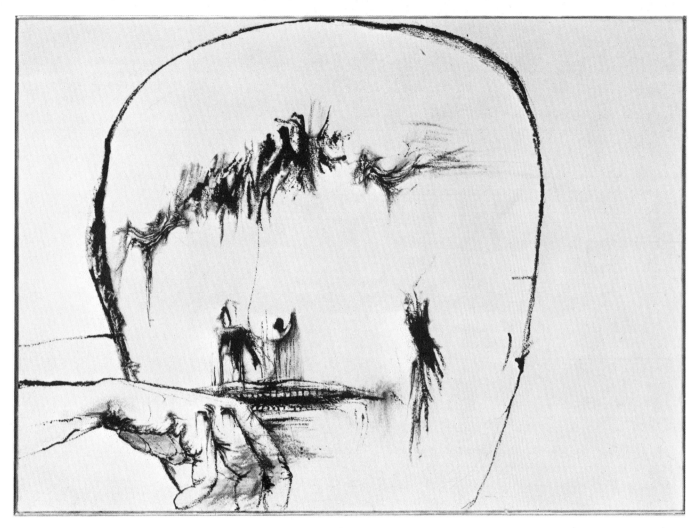

Plate 91

Leonard BASKIN · *Weeping Man*, 1956 · ink, 22½ x 31³⁄₁₆ inches · Worcester Art Museum, Worcester, Massachusetts

Plate 92

Vivian Sauber KOOS
Agip Gas, 1958
enamel on iron, 23 x 31 inches
Warren Wilentz
Metuchen, New Jersey

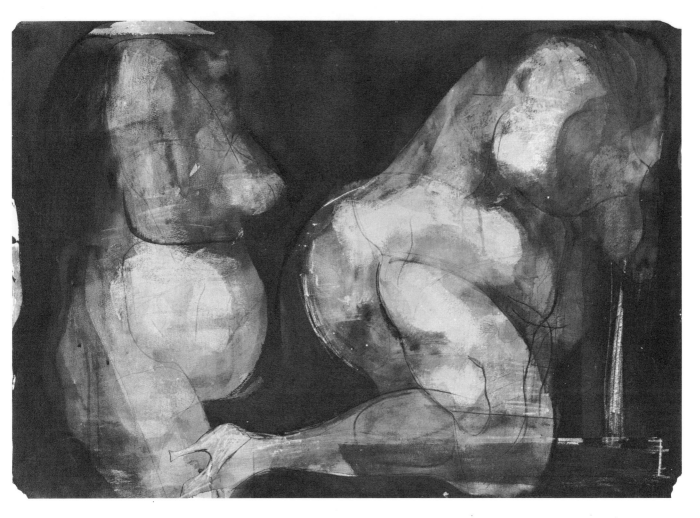

Plate 93

Rico LEBRUN • *Kneeling and Standing Figures*, 1962 • wash drawing, 27½ x 36 inches • Philadelphia Museum of Art, Pennsylvania

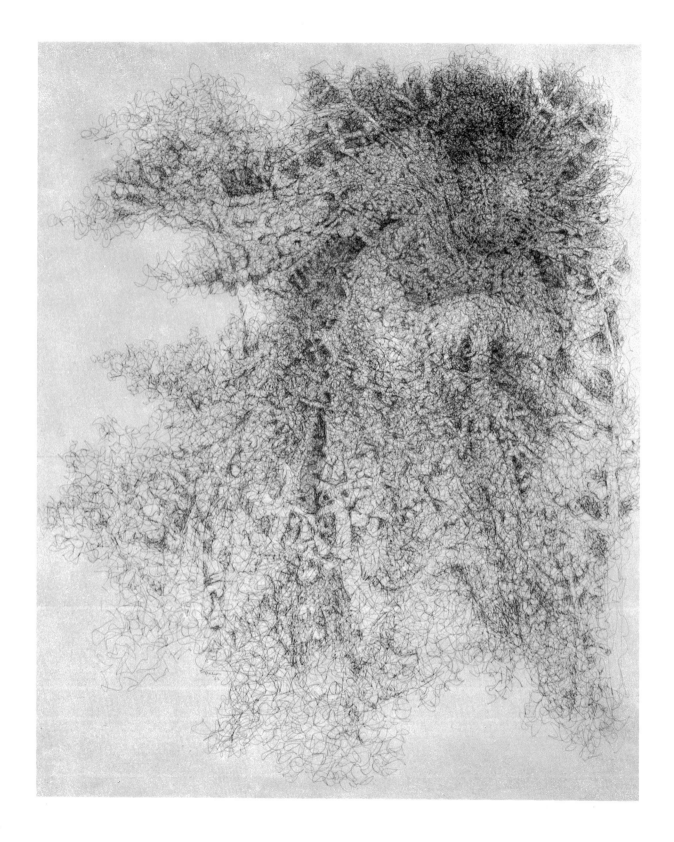

124

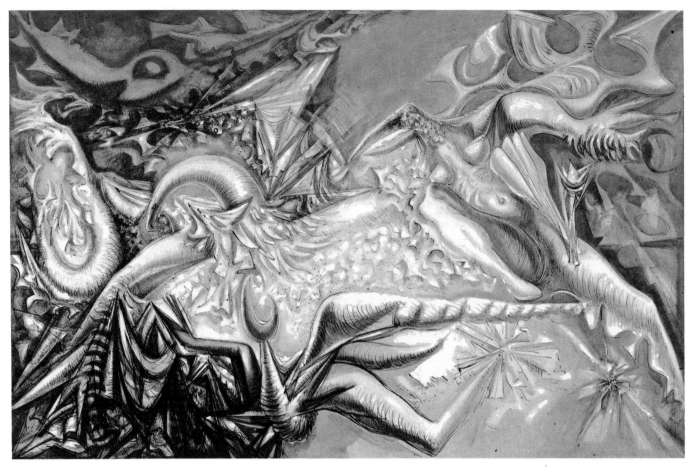

Plate 95

Theodore ROSZAK • *Study for "The Furies,"* 1950 • ink, 25 x 38¾ inches • Whitney Museum of American Art, New York

Plate 96

William WYMAN
Homage to Robert Frost, 1962
stoneware vessel
27 H x 16 W x 3½ D inches
Everson Museum of Art
Syracuse, New York
Gift of Syracuse China Corporation

Plate 97

Robert RAUSCHENBERG • *Bus Stop*, 1954 • combine drawing, 15½ x 22¾ inches • Jasper Johns, Edisto, South Carolina

Plate 98

Robert INDIANA • *The American Hay Company*, 1962 • conté crayon, 25⅛ x 19⅛ inches • Collection
The Museum of Modern Art, New York. Purchase

Biographies

AGATE
Frederick Styles Agate (1807-1844), born in Sparta, Westchester County, New York, painted portraits and historical and religious pictures. In 1826 he was elected an associate of the National Academy of Design.

ALLSTON
Washington Allston (1779-1843), born in South Carolina, was founder of the Romantic movement in American painting. His works, which document the artistic temperament of his era, are visionary scenes charged with poetic imagery.

AUDUBON
John James Audubon (1785-1851), born in Haiti and educated in France, is the most famous of the naturalist-artists who recorded the wildlife of American fields and woods. A superb designer, his careful brush created more than 400 water colors, found in his portfolio, *The Birds of America.*

BASKIN
Leonard Baskin (b. 1922) was born in New Brunswick, New Jersey, and studied art at Yale University, the New School and in Paris. He now teaches sculpture and graphic art at Smith College in Northampton, Massachusetts.

BELLOWS
George Bellows (1882-1925), born in Columbus, Ohio, was an outstanding realist of the American scene who studied under the leader of "The Eight," Robert Henri. With a powerful brush, he painted chiefly themes of action and conflict using strong contrasts. His dexterity as a draughtsman contributes to the dynamic and tense mood of his works.

BENTON
Thomas Hart Benton (b. 1889), born in Neosho, Missouri, is one of the most widely known muralists of the American scene, especially for his portrayals of Middle Western customs and landscapes.

Rejecting the abstract movements of the time, he created a new regional style of dramatic realism.

BLOOM
Hyman Bloom (b. 1913), Russian born, was a major figure in the American Expressionist movement of the thirties and early forties. Religious symbolism pervades many of his richly colored works. Although his more recent work shows a greater restraint of sensuality, he remains essentially an exponent of the romantic mood.

BROWN
Mather Brown (?-1831) was born in Boston, Massachusetts, but as a young man moved to England where he became a pupil of Benjamin West and Gilbert Stuart. Primarily a portraitist, he painted English royalty and many famous military figures. He lived and worked most of his life in England.

BULFINCH
Charles Bulfinch (1763-1844), born in Boston, Massachusetts, was an architectural designer who combined the Adams style (English Neoclassicism) and the old Colonial Georgian style. His handsome church in Lancaster, Massachusetts, is one of his masterpieces.

BURCHFIELD
Charles Burchfield (b. 1893) was born in Ashtabula Harbor, Ohio. One of the most striking of the new Romantic Realists, his works manifest the conventions of small-town dwellers. Working largely in water color, Burchfield expresses his feelings of nature's rhythmic forces.

CALDER
Alexander Calder (b. 1898) was born in Philadelphia, Pennsylvania. Originally an engineer, he is now a sculptor, painter and illustrator. His invention of stabiles and mobiles is regarded as a unique contribution to the concept of sculpture.

CASSATT

Mary Cassatt (1845-1926), born in Philadelphia, became an avid student of Degas who greatly admired her draughtsmanship. Concentrating on the mother-and-child theme, her paintings and etchings show influences of French Impressionism and the Japanese print.

CHAMBERLAIN

Samuel Chamberlain (b. 1895), born in Cresco, Iowa, is a graphic artist whose etchings and drypoints have been exhibited in this country and abroad. He is also the author of numerous books on architecture and on photographic impressions of Europe and America.

CHURCH

Frederick Edwin Church (1826-1900) spent his youth in New Haven, Connecticut. Studying there for a while, he later became a pupil of Thomas Cole. His panoramic landscapes of America, the Tropics, the Near East and Europe contain much precise detail on the grandeur of nature.

COLE

Thomas Cole (1801-1848), born in England, was one of America's earliest landscape painters; he was the leader of the Hudson River school. His strength lies in his ability to endow the landscape with both sentiment and grandeur.

COLMAN

Samuel Colman (1832-1920) was a native of Portland, Maine. A water-colorist and painter of landscapes, marinescapes and architecture, he recorded his impressions during extensive travel in Europe.

COPLEY

John Singleton Copley (1738-1815) was born and raised in Boston. His technical knowledge and especially his ability to bring to life the character of his sitters, often depicting them in their natural surroundings, rank him as one of America's finest portrait painters.

COX

Kenyon Cox (1856-1919) was born in Warren, Ohio. He was an excellent draughtsman and devoted himself to the study of the Great Masters. The classical ideal is expressed in his portraits and in his mural decorations for public buildings. An academician, he opposed experimental art.

COX

Palmer Cox (1840-1924), born in Granby, Canada, was an author and illustrator of children's books. He originated a well-loved series of stories called *The Brownies*.

CROPSEY

Jasper F. Cropsey (1823-1900) was born in Rossville, Long Island, and died in Hasting-on-Hudson. At first a professional architect, he later became a landscape painter of the Hudson River area and the White Mountains at North Conway.

DAVIS

Stuart Davis (1894-1964) was born in Philadelphia and moved to New York at an early age. His most famous works translate familiar aspects of city life into a pattern of hard-edged and brightly colored shapes. His methods relate to the flattening and distortion of perspective peculiar to Cubism.

DEMUTH

Charles Demuth (1883-1935) was born in Lancaster, Pennsylvania. His paintings, illustrations from Henry James, and water colors of fruits and flowers show a strong kinship with the European aesthetic. Although he was influenced by Cubism, his strength rests on a highly refined sensitivity to both form and content.

DICKINSON

Preston Dickinson (1891-1930) was in New York and died in Spain before having reached forty. He was largely influenced by French Postimpressionism and Cubism. Working in oil, water color and

pastel, he did most of his work in the cities of New York and Quebec.

DISNEY
Walt Disney (b. 1901), born in Chicago, Illinois, is famous for having established the well-loved animated cartoon as a popular and creative medium.

DOUGHTY
Thomas Doughty (1793-1856), born in Philadelphia, was a member of the Hudson River school. Although he attempted to capture something of Thomas Cole's dynamism, he preferred the tranquil pastoral landscapes of New York and the Catskills. Doughty was also an accomplished lithographer.

DOVE
Arthur Dove (1880-1946) was born in Canandaigua, New York. His concentration on spontaneous expression of inner feelings and his elimination of many representational elements seem to foreshadow the movements of the fifties, especially Abstract Expressionism. He was one of the first Americans to experiment with collage.

DUNLAP
William Dunlap (1766-1839), born in Perth Amboy, New Jersey, was a painter, etcher, dramatist and author. He participated in this country's first important exhibition of etchings and was first to publish a history of the arts in America.

DURAND
Asher B. Durand (1796-1886), born in Jefferson, New Jersey, was a member of the Hudson River school. He depicted the Catskill region poetically and as a place for humanity. His style, sensitive in detail and line, reveals his original profession of engraving.

EAKINS
Thomas Eakins (1844-1915) was born in Philadelphia, Pennsylvania, where he lived and worked. He received strict technical training from Gerôme, in Paris, but unlike the academicians he chose to depict the reality of the everyday themes he knew. Eakins' paintings form a vital link between the early American realists and the modern objective spirit.

EDMONDS
Francis W. Edmonds (1806-1863), born in Hudson, New York, was a bank clerk who began his career as a "Sunday painter." With little formal art education, he did portraits and witty genre works of rural America. His meticulous, anecdotal realism reminds one of the work of William Sidney Mount.

FEININGER
Lyonel Feininger (1871-1956), born in New York, was originally a caricaturist. Later, under the influence of the Cubists, *der Blaue Reiter* and eventually the Bauhaus, he originated a style of painting which consisted of shifting planes and seemingly transparent rainbow hues. While his early works feature old German towns, his later ones are poetic interpretations of New York skyscrapers.

FINE
Perle Fine (b. 1915), born in Boston, Massachusetts, studied painting at The Art Students League and was also a pupil of Hans Hofmann. Her work is of the Abstract Expressionist school.

FLANNAGAN
John B. Flannagan (1895-1942), born in Fargo, North Dakota, was a sculptor. His first expressionistic carvings in wood are gothic-like, tormented figures, while his later sculptures of animals, insects and figures employ more rounded personal forms.

GANSO
Emil Ganso (1895-1941) was born in Halberstadt, Germany. A painter of the figure, landscape and still life, he is known equally as a graphic artist.

His delicate but competently drawn nudes are considered among his best works.

GARBER
Daniel Garber (1880-1958), born in North Manchester, Indiana, was considered one of the founders of the Delaware Valley school of landscape painting. His work illustrates the influence that French Impressionism had on many early 20th-century American artists.

GLASCO
Joseph Glasco (b. 1925) was born in Paul's Valley, Oklahoma. An abstract painter, he uses obscure symbols and strange linear patterns to describe the enigmatic world of the subconscious.

GORKY
Arshile Gorky (1904-1948), born in Armenia, has been a constant and powerful influence on American abstract painters. Ultimately discarding the image, he relied on the positive value of spontaneity to create forms which bore no direct relation to the visual world—establishing the creative "act" as self-sufficient.

GOTTLIEB
Adolf Gottlieb (b. 1903), born in New York City, is an abstract painter whose work has elements of a primal symbolism. He was among the first painters to use the "accident" as a part of his technique.

GRAVES
Morris Graves (b. 1910), born in Fox Valley, Oregon, traveled in Japan, France and Mexico. His works, which are tinged with Oriental mysticism, suggest a subjective dreamlike world.

HARTLEY
Marsden Hartley (1877-1943), born in Lewiston, Maine, was among the adventurous group of young American painters first to respond to the European movements of Cubism, Fauvism and *der Blaue Reiter.* A vital and inventive artist, his mature style has endowed him with the reputation of one of America's important 20th-century artists.

HASELTINE
William Stanley Haseltine (1835-1900), born in Philadelphia, spent much time in Germany where he painted motifs of the Rhine Valley, and in Italy where he did oil sketches and drawings of the Italian landscape. The latter depart from his original romantic-classical leanings.

HERRIMAN
George Herriman (1881-1944) was born in New Orleans. He won fame as the author of the cartoon strip "Krazy Kat," which he wrote for King Features Syndicate. He is also remembered by the connoisseurs of the medium as creator of "The Dingbat Family" and "Baron Bean."

HIRSCHFELD
Albert Hirschfeld (b. 1903), illustrator and caricaturist, was born in St. Louis, Missouri, and studied at the National Academy of Design and The Art Students League in New York. He has been theater caricaturist for *The New York Times* since 1926.

HOFMANN
Hans Hofmann (b. 1880) was born in Germany, but since the Nazi persecution of artists, he has lived in the United States. He formed his new style of abstract, dynamic and colorful paintings from 1940 to 1944 and has inspired much of the work of Abstract Expressionists. As a teacher, Hofmann has exerted an enormous influence on the younger artists of the last two decades.

HOMER
Winslow Homer (1836-1910), born in Boston, began his career as an illustrator working in the narrative style. One of the 19th century's great painters, Homer did a prodigious number of oils and water colors. His powerfully designed paintings

of the sea often depict man in conflict with the forces of nature.

HOOD

Dorothy Hood (b. 1919), born in Bryan, Texas, is primarily a pen-and-ink artist. Her drawings are executed in minute and labyrinthine swirls, producing a surreal and seemingly psychological intent; her titles suggest the poetic nature of her work.

HOPPER

Edward Hopper (b. 1882), born in Nyack, New York, was a pupil of Robert Henri, William Merritt Chase and Kenneth Hayes Miller. Throughout the many drastic innovations of art in this century, he has maintained his own style, a mixture of realism and idealism that is romantic in mood if not in outward form.

HUNTINGTON

Daniel Huntington (1816-1906), born in New York City, was a clever portraitist who painted some of the most important figures of his era. His work also includes genre, allegories, landscapes and still lifes.

INDIANA

Robert Indiana (b. 1928), born in New Castle, Indiana, attended The Art Institute of Chicago and the Edinburgh College of Art, Scotland. A Pop artist, he has had many one-man and selected group shows here and abroad.

JOHNSON

Eastman Johnson (1824-1906), born in Maine, specialized in domestic genre painting. The warm brown tonalities of his pictures and his restrained compositions show his admiration for the Little Dutch Masters.

KELCHNER

L. M. Kelchner (dates and birthplace unknown) was trained in the art of Spencerian script and worked as a commercial penman in the early part of the century. Little is known of him beyond the testament of a few decorative calligraphic drawings.

KLINE

Franz Kline (1910-1962) was born in Wilkes-Barre, Pennsylvania; he studied at the School of Fine and Applied Art, Boston University. One of the important members of the New York school of Abstract Expressionist painters, his work is dynamic as a result of the heavy brush stroke, the bold, simple shapes and movement, and the omission of color.

KOLLNER

Augustus Kollner (1813-1906), etcher, lithographer and water-colorist, was born in Württemberg, Germany. In 1839 he came to America where he achieved distinction as a lithographer, working for such firms as P. S. Duval and Thomas Sinclair. An extensive traveler, he recorded numerous views of Canadian and American cities.

de KOONING

Willem de Kooning (b. 1904) was born in Rotterdam but now lives in New York. His dynamic figurative abstractions, first exhibited in 1948, established him as one of the most important leaders (along with Pollock) of the new American painting. He often makes hundreds of preparatory drawings for each painting.

KOOS

Vivian Sauber Koos (living) was born in Barberton, Ohio, and studied art at Ohio State University. She also studied in Italy on a Fulbright grant. Her work includes mural-size enamels which express a feeling of wit and wide open space.

KUNIYOSHI

Yasuo Kuniyoshi (1893-1953) was born in Okayama, Japan. His first teacher in America was Kenneth Hayes Miller. Kuniyoshi is a painter of figures and landscapes which are conceived in a

fanciful vein and executed with delicate wash-like effects.

LACHAISE
Gaston Lachaise (1882-1935), born in Paris, studied at the Académie Nationale des Beaux-Arts before coming to America in 1906. Lachaise was a pioneer in modern American sculpture and is celebrated for his sensual and massive treatment of the female form.

LEBRUN
Rico Lebrun (b. 1900) came to the United States from Naples; he now lives and teaches in California. His painting style is forceful and individual and, although influenced by Abstractionism, it is essentially figurative.

LEUTZE
Emanuel Leutze (1816-1868), born in Germany, also studied there. A classicist, he is remembered for his widely reproduced historical painting, *George Washington Crossing the Delaware*.

LEVINE
Jack Levine (b. 1915), born in Boston, is a vehement social satirist. He depicts humanity's corruption and injustice in a personal style which may be considered an American derivation of European Expressionism.

LUKS
George B. Luks (1867-1933), painter and illustrator, was born in Williamsport, Pennsylvania. An original member of the American realist group, "The Eight," he believed that art must concern itself with life. He selected his subjects from the streets and painted them in a broad and self-confident manner.

MARIN
John Marin (1870-1953), born in Rutherford, New Jersey, became one of America's leading watercolorists. He spent several years studying in Paris. Known chiefly for his coastal scenes of Maine and New Jersey, Marin's style consists of tilting planes and stenographic symbols.

MARSH
Reginald Marsh (1898-1954), born in Paris, was a painter and illustrator who studied under Luks and Sloan. An artist who felt a kinship with the European tradition of draughtsmanship, Marsh vividly recorded the urban American scene of the thirties and forties.

MAURER
Louis Maurer (1832-1932), father of the painter Alfred Maurer, was born in Biebrich, Germany, and came to America at the age of 19. A painter and lithographer, he did many of the scenes used for the Currier and Ives prints.

MORAN
Thomas Moran (1837-1926), born in Lancashire, England, was a painter and etcher. His canvasses often depict such subjects as the Grand Canyon and the Sierra Nevada Mountains.

MOUNT
William Sidney Mount (1807-1868) was born in Setanket, Long Island. A consummate craftsman, he won fame for his genre pictures which warmly narrate episodes of farm and country life.

NADELMAN
Elie Nadelman (1885-1946), born in Poland, was prominent among the European avant-garde sculptors of the early 20th century. Although his early work was affected by Cubism, his final synthesis relates his sculptures both to classical antiquity and to the simple folk art of America. In 1914 he moved to the United States where he spent his life working in semiseclusion.

NAST
Thomas Nast (1840-1902), painter and illustrator, was born into a family of German refugees in Landau, Bavaria. As a staff artist for *Harper's Weekly*, he did vitriolic caricatures which established him

as one of America's most forceful political cartoonists and satirists.

NELSON

Carl Gustaf Nelson (b. 1898) was born in Horby, Sweden. He is a painter and graphic artist and was originally a student of Kimon Nicolaides at The Art Students League in New York. He is particularly known for the park scenes which he painted during the thirties.

PAPPAS

Marilyn R. Pappas (b. 1931) was born in Brockton, Massachusetts, and studied at The Massachusetts College of Art. Working in the medium of collage, she executes wall hangings which combine the use of cloth materials with techniques of stitching and appliqué.

POLLOCK

Jackson Pollock (1912-1956), born in Cody, Wyoming, studied art with both Thomas Benton and Hans Hofmann. By 1940 he had arrived at a completely nonconformist type of painting using the method known as "drip." Pollock is one of the most important artists (along with de Kooning) in the development of Abstract Expressionism.

POTTHAST

Edward Henry Potthast (1857-1927) was born in Cincinnati, Ohio. He studied in Cincinnati, Munich and Paris, and became a member of the National Academy of New York in 1906. A realist, he painted figures, landscapes and seascapes.

PRENDERGAST

Maurice Prendergast (1859-1924) was born in St. John's, Newfoundland. Despite his association with the famous "Eight" and his strong affinity for French Impressionism, his style remained highly personal and interpretive.

RAUSCHENBERG

Robert Rauschenberg (b. 1925), born in Port Arthur, Texas, is a painter who combines images of popular culture with Abstract Expressionist methods. Some of his Cubist-oriented collages have served as a stimulus for Neo-Dada.

REMINGTON

Frederic Remington (1861-1907), born in New York State, was a painter, sculptor and illustrator. He is America's most celebrated portrayer of the West, its cowboys and its open range. Skillfully capturing the drama of his subjects, Remington depicted frontier life with exacting knowledge of detail.

RIMMER

William Rimmer (1816-1879) was born in England and died in South Milford, Massachusetts. Best known for his sculptures, he also painted a world of surrealistic imagery derived from dreams and obsessive fantasy.

ROSZAK

Theodore Roszak (b. 1907) was born in Poznan, Poland, and now lives in New York. His metal sculptures exhibit the fluid, expressionistic idiom developed by American sculptors in the forties.

ST. MEMIN

Charles Balthazar Julien Févret de Saint-Mémin (1770-1852) was born in Dijon, France. Working in a specialized branch of portraiture, he engraved miniature profiles of some of society's leading figures. The Corcoran Gallery of Art in Washington, D. C., owns a complete set of 800 of these works.

SARGENT

John Singer Sargent (1850-1925), born in Florence, Italy, into a wealthy and cultivated family, was a painter of the fashionable leisure class. His skill in capturing character and setting with a broad, casual brush made him a brilliant interpreter of his worldly milieu.

SHAHN

Ben Shahn (b. 1898) left Lithuania as a young

child for the United States. After working as an apprentice to a lithographer (he began at 16), he traveled and studied in Europe. Many of his oil paintings, illustrations and lithographs of American life express his concern with society's evils.

SHEELER
Charles Sheeler (b. 1883) was born in Philadelphia, Pennsylvania. An exhibitor in The Armory Show of 1913, he is famous for his Cubist-influenced interpretations of the American industrial landscape. His sharply delineated images are conceived in perfectly clear focus.

SHIRLAW
Walter Shirlaw (1838-1909), born in Paisley, Scotland, was one of the original founders of the Chicago Academy of Design. His work includes genre and landscape painting, etching, stained-glass windows and murals—one of which was commissioned by the Library of Congress.

SKLAR
George Sklar (b. 1905), born in Philadelphia, paints wild and domestic animals. In 1947 the New York Museum of Natural History displayed his bold brush drawings.

STEINBERG
Saul Steinberg (b. 1914), born in Budapest, Rumania, studied sociology, psychology and architecture before turning to the graphic arts. He has satirized American life through posters, drawings, illustrations and murals in a caustic, almost cruel, and yet humorously inventive style.

STELLA
Joseph Stella (1880-1946), born in Murco-Lucano, Italy, came to the United States in 1900. A Futurist, Stella interpreted the dynamics of 20th-century technology both romantically and powerfully, as illustrated by his well-known painting, *The Brooklyn Bridge*.

STERNE
Maurice Sterne (1877-1957), born in Libau, Latvia, was a sculptor, lithographer and painter who studied in this country with Thomas Eakins. On his return to Europe he came under the influence of Cézanne, Derain and Gauguin. Although he retained an avid interest in draughtsmanship, his style subsequently took on aspects of Postimpressionism.

SULLY
Thomas Sully (1783-1872), born in Lincolnshire, England, was a Romantic painter most famous for his portraits. An admirer of Sir Thomas Lawrence, his work reflects the tradition of Romantic English portraiture. He also painted a number of historical compositions.

THAYER
Abbott Henderson Thayer (1849-1921), born in Boston, Massachusetts, was a student of the Parisian ateliers. His many portraits of the idealized woman reflect much technical skill and reveal the didactic trend in American painting of his period.

TOBEY
Mark Tobey (b. 1890), born in Wisconsin, traveled in Europe and the Far East, and now lives in Seattle. His invention in painting, "white writing," is based on the technique of Chinese calligraphy.

TRUMBULL
Colonel John Trumbull (1756-1843), born in Lebanon, Connecticut, was a narrative painter of American historical events. An impressive example of his painting is his mural commissioned for the rotunda of the nation's Capitol.

VANDERLYN
John Vanderlyn (1775-1852), born in Kingston, New York, was trained in the tradition of European neoclassicism. His somewhat rhetorical can-

vasses show unusual competence in the handling of his craft.

VEDDER
Elihu Vedder (1836-1923), born in New York, was a mystic painter like Alfred P. Ryder and Ralph Blakelock. While living in Europe he painted many lovely small canvasses which reveal him as a painter of the contemplative mood. His works include illustrations from *The Rubaiyat* of Omar Khayyam as well as mural commissions for The Library of Congress.

WEBER
Max Weber (1881-1961), born in Russia, was one of America's earliest pioneers in modernism. His religious nature is revealed in his early themes of prayer and contemplation. His later paintings are characterized by a freely distorted naturalism.

WEIR
Julian Alden Weir (1852-1919), born in West Point, New York, was a painter and etcher. As an American Impressionist and a member of "The Ten," he was among the first to attempt a break with academic rules and to experiment with familiar subjects in their natural lighting.

WEST
Benjamin West (1738-1820) was born in Philadelphia, Pennsylvania. Early study abroad introduced him to the neoclassical ideal in painting which was flourishing in Italy. Although settling in England, he often drew his themes from the annals of American history for his monumental and dignified compositions.

WHISTLER
James Abbott McNeill Whistler (1834-1903), the son of an army engineer, was born in Lowell, Massachusetts, and spent his childhood in Russia. He was, at first, a pupil of Courbet in Paris, but soon after allied himself with the Impressionists. Whistler later went to England where he won distinction for his poetic style and his promotion of "art for art's sake."

WILLIAMS
W. A. Williams (dates and birthplace unknown) is an unknown American artist, identified only by the drawing, *View of Hell Gate,* signed and dated 1777. He was most probably a mapmaker by profession.

WOOD
Grant Wood (1892-1942) was born in Anamosa, Iowa. Largely self-taught, he was a regionalist painter who depicted familiar places and people of the Middle West with the precision of the early Flemish and German painters.

WRIGHT
Frank Lloyd Wright (1869-1959), born in Michigan, was one of America's most significant 20th-century architects. Opposing the skyscraper, industrialization, and the anonymous city, Wright concentrated on what he called "organic" architecture: form determined by function. He was concerned with human values, the landscape and plain building materials.

WYETH
Andrew Newell Wyeth (b. 1917) was born in Chadds Ford, Pennsylvania. He is a concise draughtsman whose style combines a fastidious realism with a quiet, dreamlike vision. His subject is the familiar American scene portrayed in a mood of gentle nostalgia.

WYMAN
William Wyman (b. 1922), born in Boston, Massachusetts, is a ceramic artist. Within the boundaries of his craft, he makes use of unorthodox, inscribed forms which seem to combine the arts of drawing and sculpture. His pottery emphasizes the beauty of the simple materials with which he works.

Bibliography

GENERAL

Barker, Virgil, *American Painting—History and Interpretation,* New York, The Macmillan Co., 1950.

Baur, John I. H., editor, *New Art in America: 50 American Painters in the 20th Century,* New York, New York Graphic Society and Frederick A. Praeger, Inc., 1957.

Baur, John I. H., *Revolution and Tradition in Modern American Art,* Cambridge, Mass., Harvard University Press, 1951.

Bénézit, Emanuel, *Dictionnaire critique et documentaire des peintres, sculpteurs, dessinateurs et graveurs,* Nouv. Ed., Paris, Grund, 1948-1955.

Born, Wolfgang, *American Landscape Painting; An Interpretation,* New Haven, Conn., Yale University Press, 1948.

Brion, Marcel, *Art Since 1945,* New York, Harry N. Abrams, Inc., 1958.

Brown, Milton W., *American Painting from the Armory Show to the Depression,* Princeton, N. J., Princeton University Press, 1955.

Bryan, Michael, *Bryan's Dictionary of Painters and Engravers,* New Edition, revised by George C. Williamson, London, G. Bell & Sons, 1903-4.

Cahill, Holger and Barr, Alfred H., Jr., *Art in America, a Complete Survey,* New York, Reynal and Hitchcock, 1935.

Flexner, James Thomas, *The Pocket History of American Painting,* New York, Pocket Books, Inc., 1950.

Flexner, James Thomas, *That Wilder Image,* Boston, Little, Brown and Co., 1962.

Gilbert, Dorothy B., editor, *Who's Who in American Art,* New York, R. R. Bowker Co., 1962.

Goodrich, Lloyd, *Pioneers of Modern Art in America,* New York, Whitney Museum of American Art, 1946.

Hunter, Sam, *Modern American Painting and Sculpture,* New York, Dell Publishing Co., Inc., 1959.

Larkin, Oliver W., *Art and Life in America,* New York, Holt, Rinehart and Winston, Inc., 1949.

Mendelowitz, Daniel M., *A History of American Art,* New York, Holt, Rinehart and Winston, Inc., 1960.

Neuhaus, Eugene, *The History and Ideals of American Art,* Stanford, California, Stanford University Press, 1931.

Pierson, William H., Jr., and Davidson, Martha, editors, *Arts of the United States,* New York, McGraw-Hill Book Co., Inc., 1960.

Richardson, Edgar P., *American Romantic Painting,* edited by Robert Freund, New York, E. Weyhe, 1944.

Richardson, Edgar P., *Painting in America,* New York, Thomas Y. Crowell Co., 1956.

Thieme, Ulrich and Becker, Felix, *Allgemeines Lexikon der Bildenden Künstler,* Leipzig, W. Engelmann, 1907.

ALLSTON

Richardson, Edgar P., *Washington Allston,* Chicago, University of Chicago Press, 1948.

AUDUBON

Ford, Alice, *Audubon's Animals: The Quadrupeds of North America,* New York, Studio Publications, Inc., 1951.

Herrick, Francis Hobart, *Audubon the Naturalist,* New York and London, D. Appleton, 1917.

BELLOWS

Eggers, George W., "George Bellows," *American Artists Series,* New York, Whitney Museum of American Art, 1931.

CASSATT

Breeskin, Adelyn D., *The Graphic Works of Mary Cassatt,* New York, Bittner, 1948.

Sweet, Frederick A., *Sargent, Whistler and Mary Cassatt,* Chicago, The Art Institute of Chicago, 1954.

Watson, Forbes, "Mary Cassatt," *American Artists Series,* New York, Whitney Museum of American Art, 1932.

COLE

Seaver, Esther I., *Thomas Cole,* Hartford, Conn., Wadsworth Atheneum, 1949.

COPLEY

Copley, John S., *Letters and Papers of John Singleton Copley and Henry Pelham, 1739-1776,* Boston, Massachusetts Historical Society, 1914.

Flexner, James T., *John Singleton Copley,* Boston, Houghton Mifflin Co., 1948.

DEMUTH

Ritchie, Andrew C., *Charles Demuth,* New York, Museum of Modern Art, 1950.

DURAND

Sweet, F. A., "Pioneer American Landscape Painter," *Art Quarterly,* v. 8, no. 2, 1945.

EAKINS

McKinney, Roland J., *Thomas Eakins,* New York, Crown Publishers, Inc., 1942.

HARTLEY

McCausland, Elizabeth, *Marsden Hartley,* Minneapolis, Minn., University of Minnesota Press, 1952.

HOMER

Goodrich, Lloyd, *Winslow Homer,* New York, The Macmillan Co., 1944.

HOPPER

Goodrich, Lloyd, *Edward Hopper,* (The Penguin Modern Painters), Harmondsworth, Middlesex, England, Penguin Books Limited, 1950.

JOHNSON

Baur, John I. H., *An American Genre Painter, Eastman Johnson, 1824-1906,* New York, Brooklyn Institute of Arts and Sciences, 1940.

de KOONING

Hess, Thomas B., "Willem de Kooning," *The Great American Artists Series,* New York, George Braziller, Inc., 1959.

MARIN

Helm, MacKinley, *John Marin,* Boston, Pellegrini and Cudahy, 1948.

PRENDERGAST

Breuning, Margaret, "Maurice Prendergast," *American Artists Series,* New York, Whitney Museum of American Art, 1931.

REMINGTON

McCracken, Harold, *Frederick Remington, Artist of the Old West—with a bibliographic check list of Remington's pictures and books,* Philadelphia, J. B. Lippincott Co., 1947.

SARGENT

McKibben, David, *Sargent's Boston, with an essay and bibliographical summary and a complete check list of Sargent's portraits,* Boston, Museum of Fine Arts, 1956.

Mount, Charles Merrill, *John Singer Sargent, a biography,* New York, W. W. Northton and Co., Inc., 1955.

SULLY

Biddle, Edward and Fielding, Mantle, *The Life and Works of Thomas Sully, 1783-1872,* Philadelphia, M. Fielding, 1921.

TRUMBULL

Sizer, Theodore, *The Works of Colonel John Trumbull, Artist of the American Revolution,* New Haven, Conn., Yale University Press, 1950.

VANDERLYN

Schoonmaker, Marius, *John Vanderlyn, Artist, 1775-1852,* New York, The Senate House Museum, 1950.

WEST

Evans, Grose, *Benjamin West and the Taste of His Times,* Carbondale, Ill., Southern Illinois University Press, 1959.

Marceau, Henri and Kimball, Fiske, *Benjamin West, 1738-1820,* Philadelphia, Philadelphia Museum of Art, 1938.

WHISTLER

Whistler, James A. M., *The Gentle Art of Making Enemies, As Pleasingly Exemplified in Many Instances,* London, Heinemann, 1916.

Pennell, Elizabeth R., *The Life of James McNeill Whistler,* 6th ed., Philadelphia, J. B. Lippincott Co., 1919.

WRIGHT

Hitchcock, Henry-Russell, *In the Nature of Materials, 1887-1941; The Buildings of Frank Lloyd Wright,* New York, Duell, Sloan & Pearce, Inc., 1942.

Wright, Frank Lloyd, *An Autobiography,* New York, Duell, Sloan & Pearce, Inc., 1943.

Art - U.S. - NA 2010